# The 50th International Eucharistic Congress Dublin 2012

## A CELEBRATION IN PICTURES AND WORDS

VERITAS

This record in pictures and words of the 50th International Eucharistic Congress will, it is hoped, be a worthy popular souvenir of the great event held in Dublin from 10–17 June, 2012. Not claimed as a complete and total pictorial record of the week-long activities, it nevertheless hopes to give a flavour of the proceedings, and seeks to record the popular esteem in which the event was received and held by all those who attended it. To this end, there appears throughout the following pages testimonials from a small number of those present at different events and in different capacities throughout the week. Likewise, the photographs included endeavour to portray the national and international flavour of the Congress, as well as documenting in some small detail the great opening and closing Masses in the RDS and Croke Park.

The 50th International Eucharistic Congress
Dublin 2012

A celebration in pictures and words

Published 2012 by
Veritas Publications
7–8 Lower Abbey Street
Dublin 1
Ireland
publications@veritas.ie
www.veritas.ie

ISBN 978 1 84730 410 0

10 9 8 7 6 5 4 3 2 1

Designed by Dara O'Connor, Veritas
Printed in Ireland by W&G Baird Ltd, Antrim

Veritas books are printed on paper made from the wood pulp of managed forests. For every tree felled, at least one tree is
planted, thereby renewing natural resources.

## FOREWORD

For seven days in June 2012, Dublin played host to the 50th International Eucharistic Congress – a celebration endeavouring to promote an awareness of the central place of the Eucharist in the life and mission of the Catholic Church; to help improve the understanding and celebration of the liturgy; and to draw attention to the social dimension of the Eucharist. It was a happy coincidence that the timing of the Eucharistic Congress coincided with the 50th anniversary of the beginning of Vatican II. It was also an opportunity to explore the extent to which we have been shaped by the reforms proposed by Vatican II.

From all across the island and the world came the faithful, to join together in this community, in this fellowship, in this communion, to engage with one another, to speak about the current situation of their Church, to provide solace and hope and support and reassurance. And through the daily celebration of the Eucharist, at the heart of the Congress, and the many thought-provoking and inspiring workshops and keynote presentations came the energy and encouragement for renewal for the many thousands who took part.

The last time the Eucharistic Congress took place on these shores, 1932, the Catholic Church in Ireland occupied a very different space to the one it inhabits today. Its footing firmly assured at that time, today the Catholic Church finds itself on more shifting sands. However, a sentiment repeated again and again over the course of this year's Congress is that the whole occasion, the bringing together of the faithful and the unity experienced in the various events of the Congress can go some considerable way to pointing out opportunities for renewal and to bolstering morale to carry out this renewal. It might be evinced as a new starting point for the Church in this country, a breakwater in the ongoing uncertainty, and a chance for the Church to acknowledge and embrace the hope there is out there for the future of the faith in Ireland.

This book is proffered as a memento of the occasion, seeking to capture in limited space and format the great spectacle of those seven days, the divergent nature of the events and the worldwide cross-section of the Church community, all gathered to celebrate that communion, with Christ and with each other.

VERITAS PUBLICATIONS

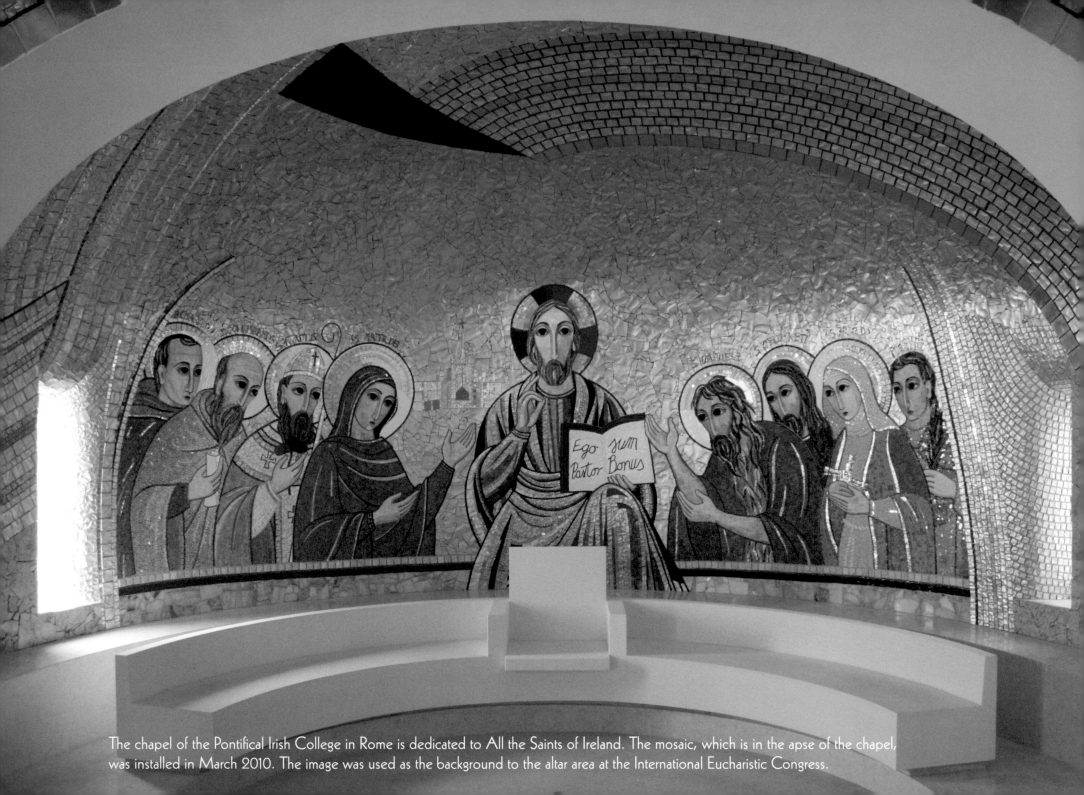

The chapel of the Pontifical Irish College in Rome is dedicated to All the Saints of Ireland. The mosaic, which is in the apse of the chapel, was installed in March 2010. The image was used as the background to the altar area at the International Eucharistic Congress.

# The 50th International Eucharistic Congress
## Dublin 2012

### The Eucharist:
### Communion with Christ
### and with One Another

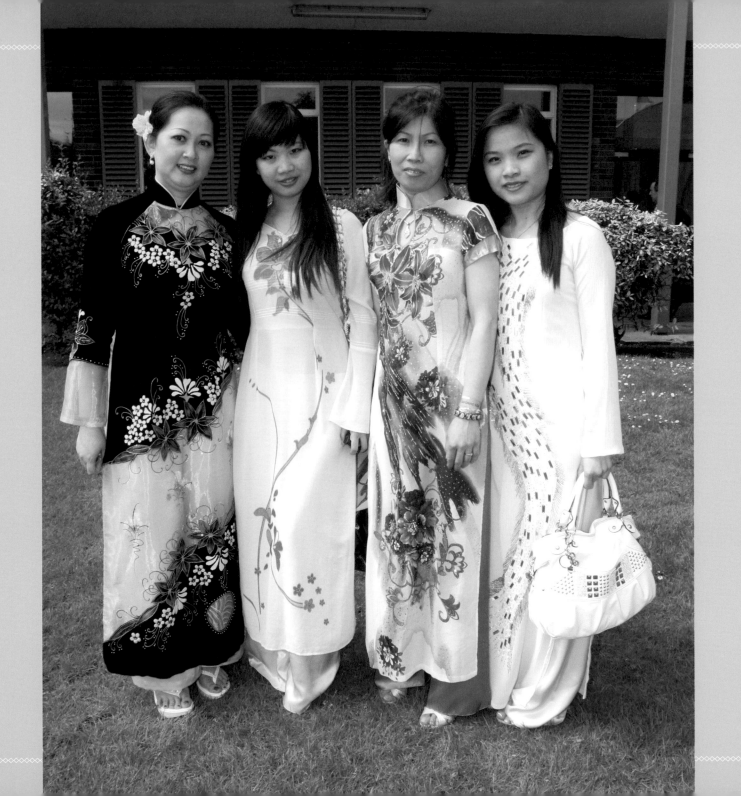

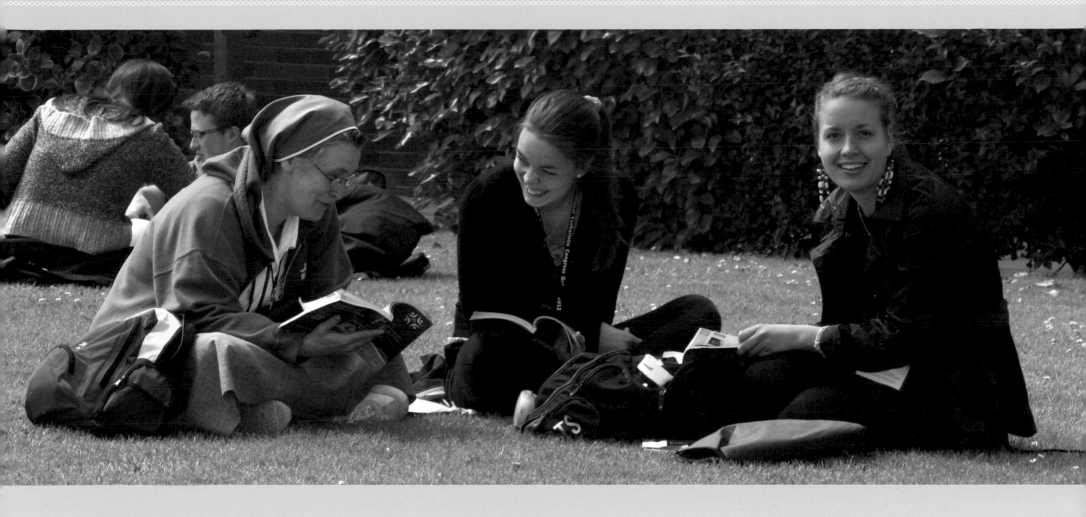

What a great event! Catholics came together in a beautiful celebration of our faith. The numbers of young people and the spiritual atmosphere during the Congress communicated the energy that comes from God's grace. I believe that when the history of our times is written, the Eucharistic Congress of 2012 will be seen as a moment of grace which marked a change, a watershed, with a 'before' and an 'after'. We are now living in the period marked by that experience of God's grace, which we have received through the presence of Jesus Christ in the Holy Eucharist.

ARCHBISHOP CHARLES BROWN

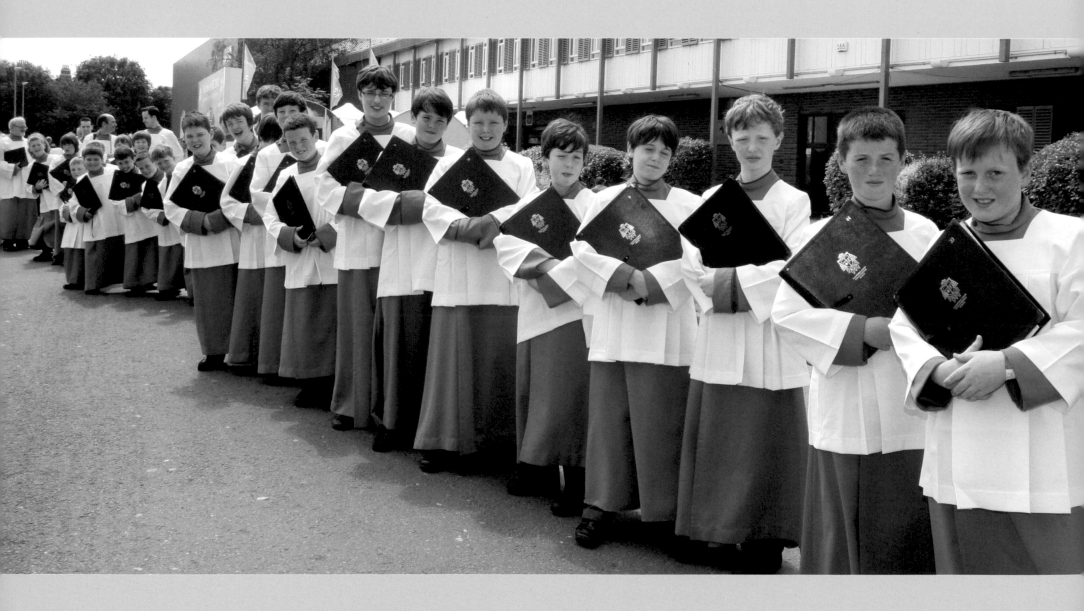

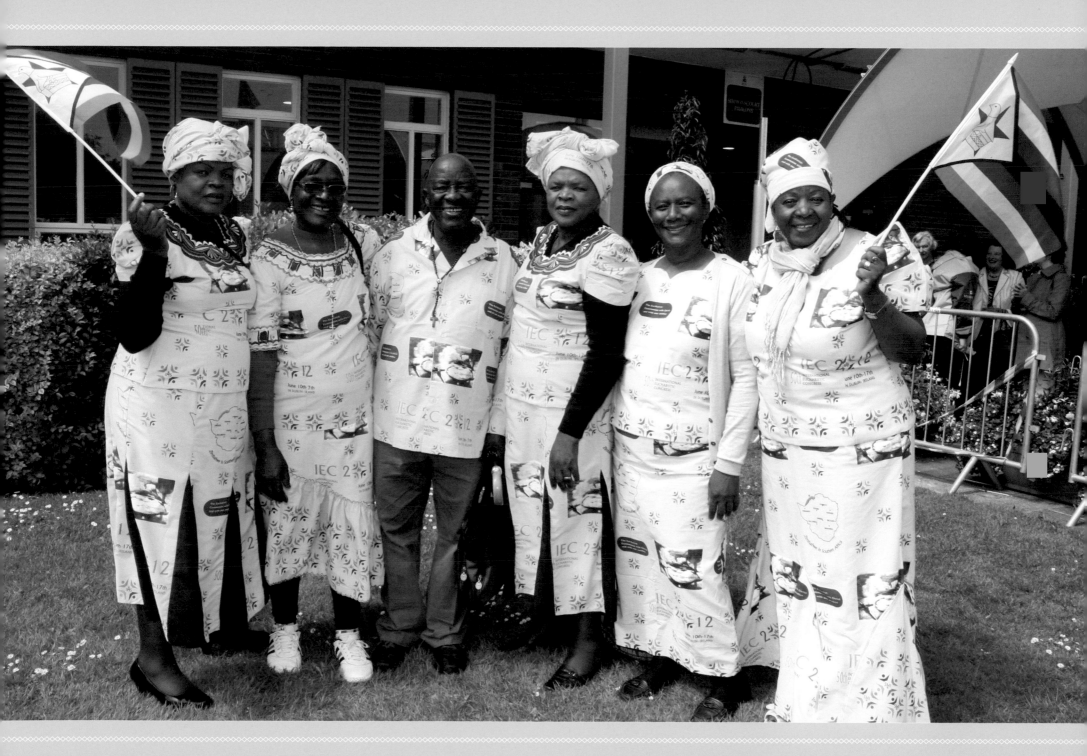

The theme of the 50th International Eucharistic Congress, 'The Eucharist: Communion with Christ and with one another', focused the mind on communion, communion with the Saviour and communion with one another by means of the Sacrament of Love and the Sign of Unity. The actual Congress, however, turned idea into event, the event of a daily-lived communion. This communion was tangible in the gracious volunteers, alive in the patience of the participants, nourished by the imaginative workshops, sensed powerfully by the young people, witnessed to by the hunger for unity as touchingly brought out on the day dedicated to ecumenism. A group of teenagers from a parish in Kilkenny came for one day, but, captivated by the atmosphere, returned twice more. The words of Pope John Paul II come to mind: 'To become the home and the school of communion: that is the great need of the Church at the beginning of the Third Millennium.' That high goal was an experience in the RDS and a mission from Croke Park, Statio Orbis.

THOMAS NORRIS

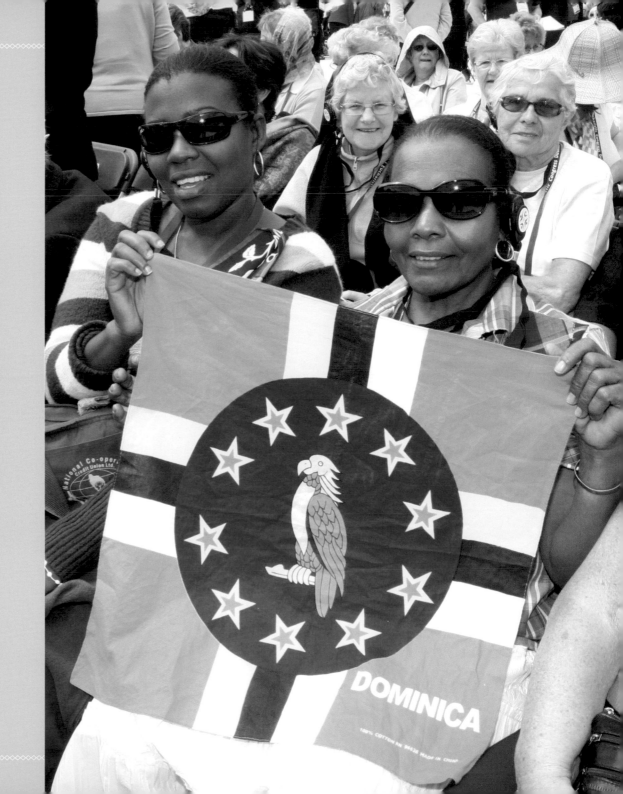

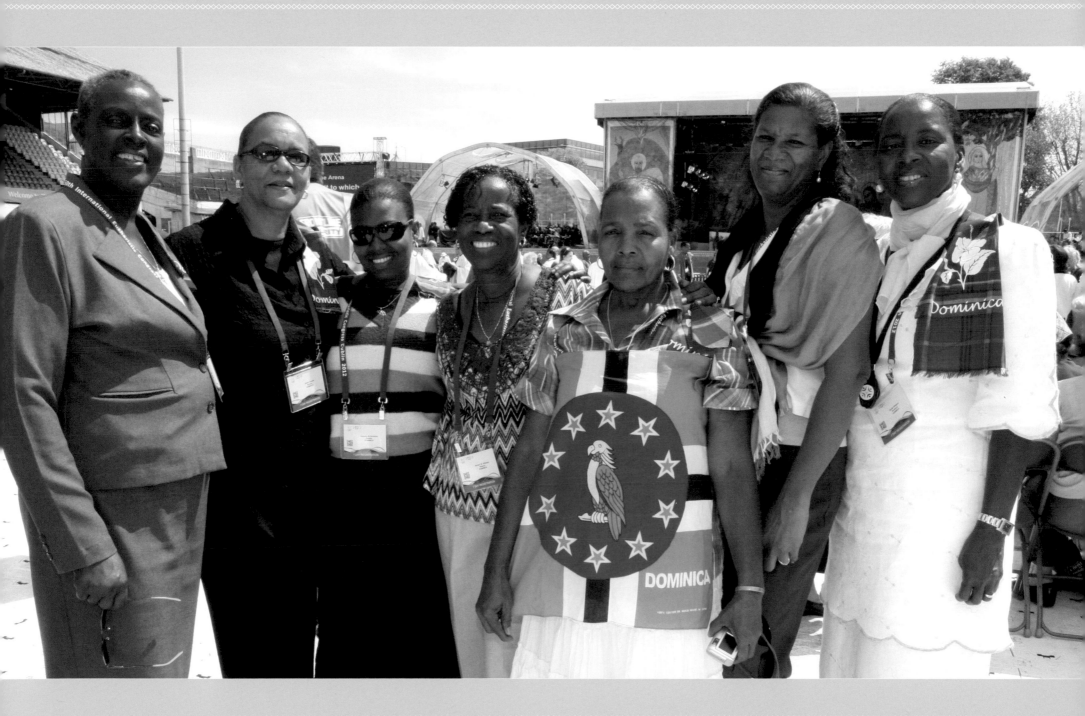

The International Eucharistic Congress was a positive and spiritual experience. One element that contributed greatly to this positive experience – replicated at the London Olympics! – was the courtesy, helpfulness and kindness of the large corps of volunteers. Another central element of the Congress was the very large number of presentations on faith and Church. The demand for these far exceeded availability, a demand that was not anticipated. It indicates a deep desire on the part of so many to learn more about their faith. Giving one of these presentations, and attending others, I was deeply impressed at the level of attention and engagement of all present.

BISHOP MICHAEL SMITH

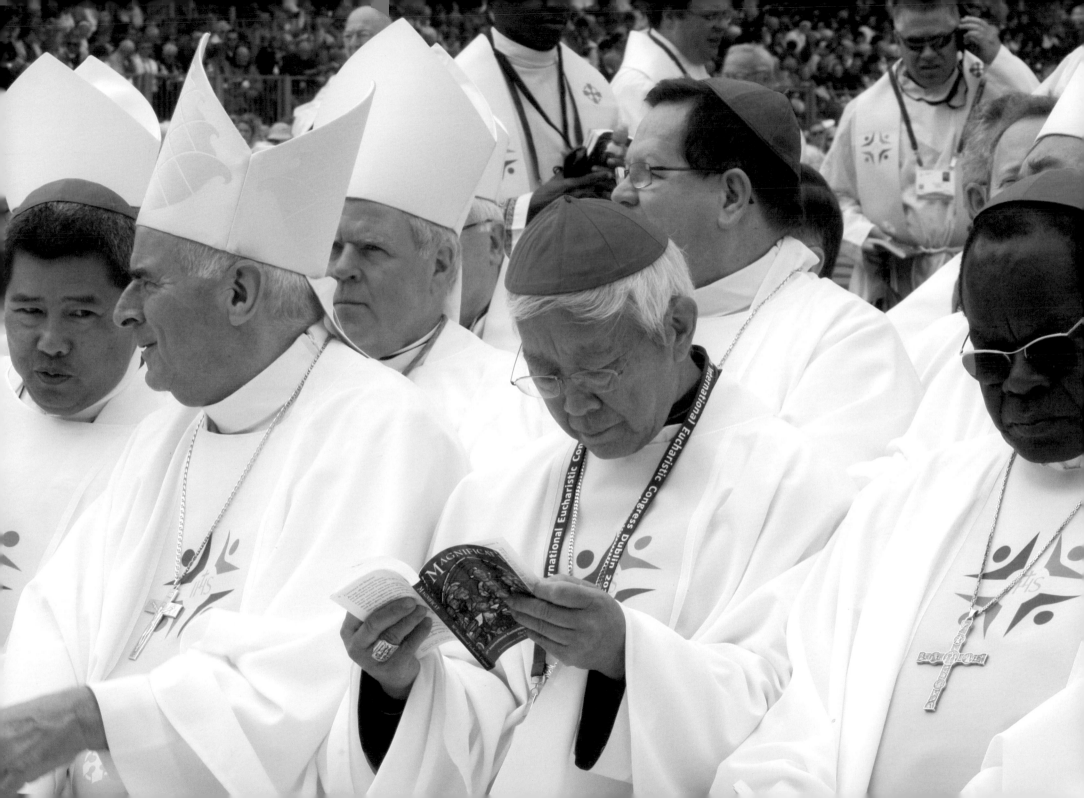

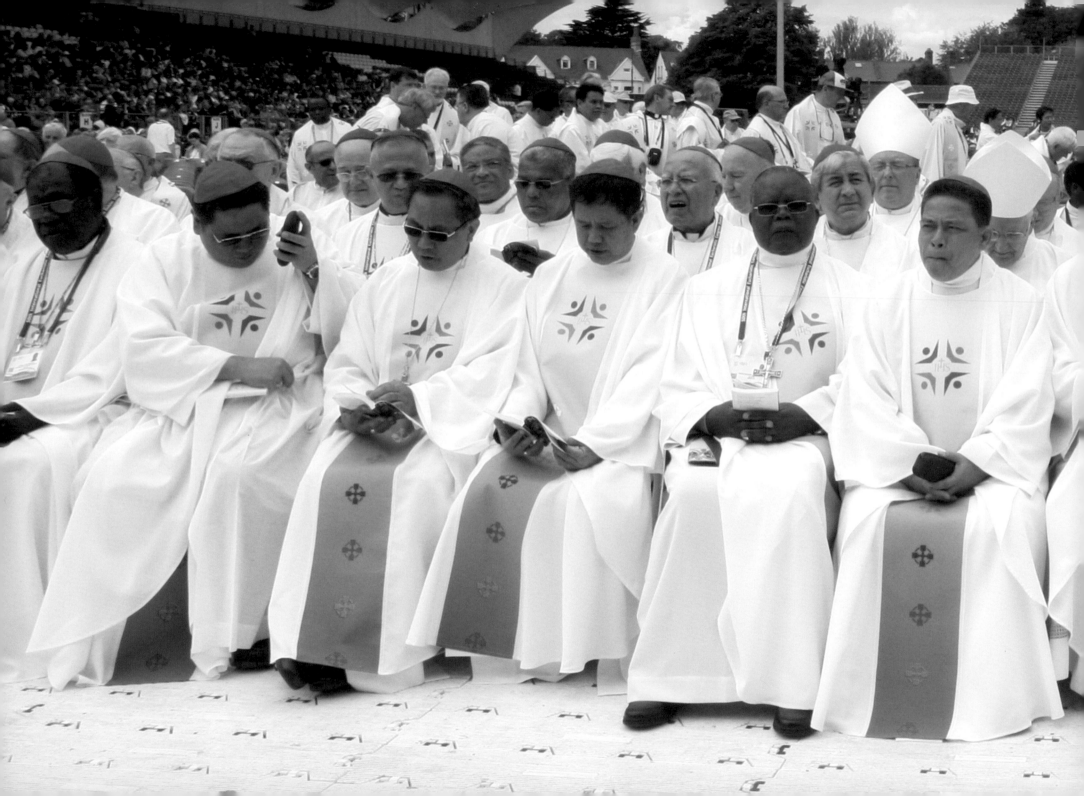

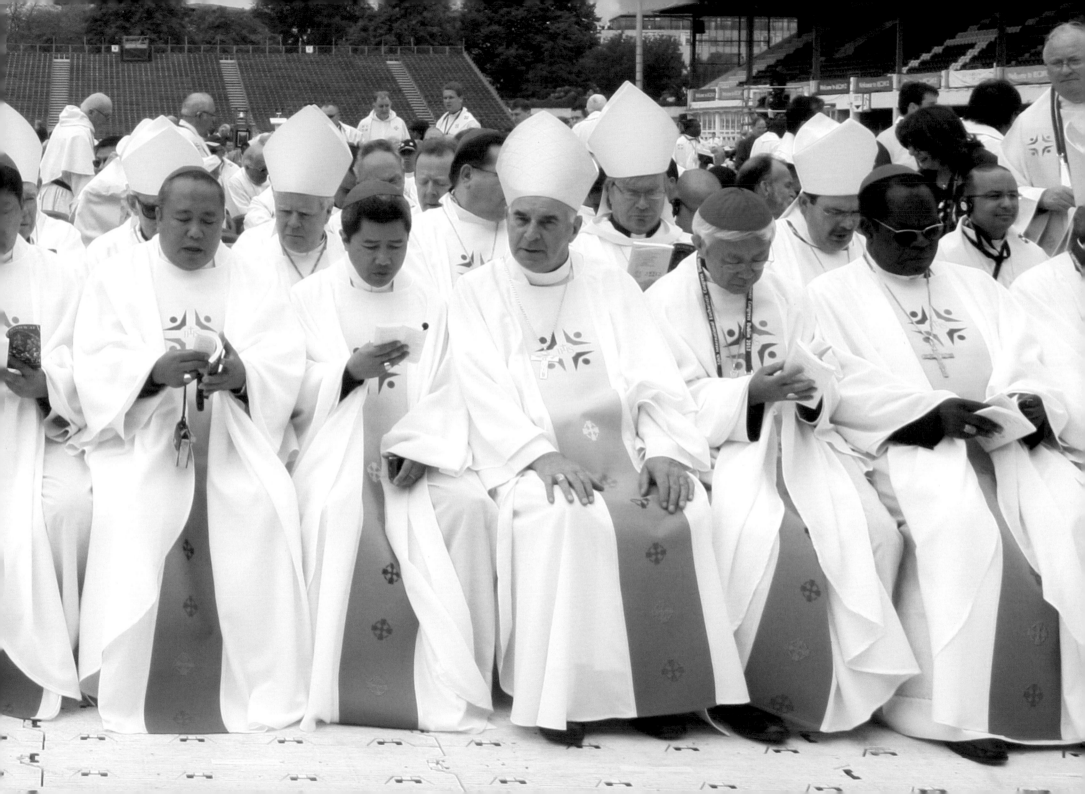

For me the Congress started a week earlier, with the theology conference in Maynooth. The first sign something special was happening was that the morning sessions given by PhD students, which I thought wouldn't be exactly crowded, were packed out. There were exciting question and answer sessions after all the talks. My favourite illustration about the power of the Eucharist came from University of Bologna economics professor, Stefano Zamagni. He told the story of the cameleer who left half his property to his eldest son, a quarter to his second, and a sixth to his third son. After he died, he left eleven camels. War broke out between the sons since eleven is a number that refuses to be divided. An elderly cameleer offered the sons his one and only camel. Now there were twelve camels, which divided into six + three + two (= eleven), giving each son his share, and the cameleer went his way with his camel. Zamagni used the story to point out that an economics based on justice wasn't enough – you also need gratuity, mercy and a little more than justice. So the Eucharist is also the basis for a Christian economics.

BRENDAN PURCELL

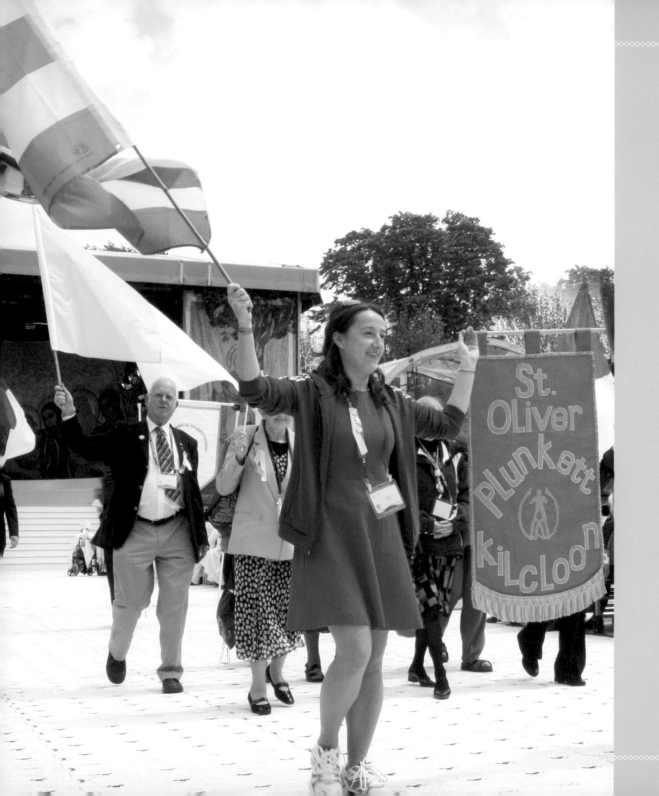

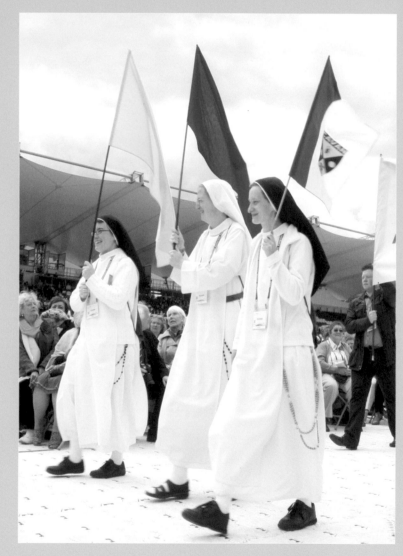

In February 2010 I started to work for the 50th International Eucharistic Congress. I was honoured to have been selected for this role, and with help from a wonderful team of staff, volunteers, committee members, supporters, speakers and many great suppliers and partners, we delivered eleven days of exceptional events. For the 100,000 pilgrims who attended and the many more who joined us by TV, radio and web, thank you. Without you, our work would have been in vain.

ANNE GRIFFIN

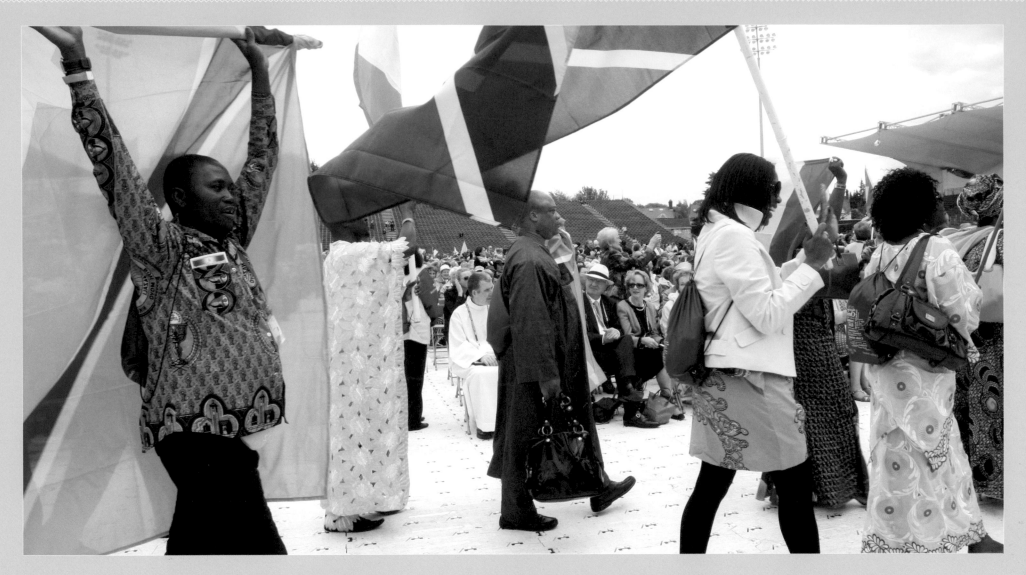

The Eucharistic Congress was a 'spiritual pick-me-up' for everyone who attended it. Morale in the Irish Church might be generally low at present but the atmosphere at the Congress was upbeat and positive. People who went found the mood infectious. They were delighted to meet fellow Christians at a major Christian event. The Church was present in all its multi-faceted dimensions. It reminded us how catholic the Church really is and of all the good work thousands of Catholics up and down the country are doing every day in many different kinds of apostolates.

DAVID QUINN

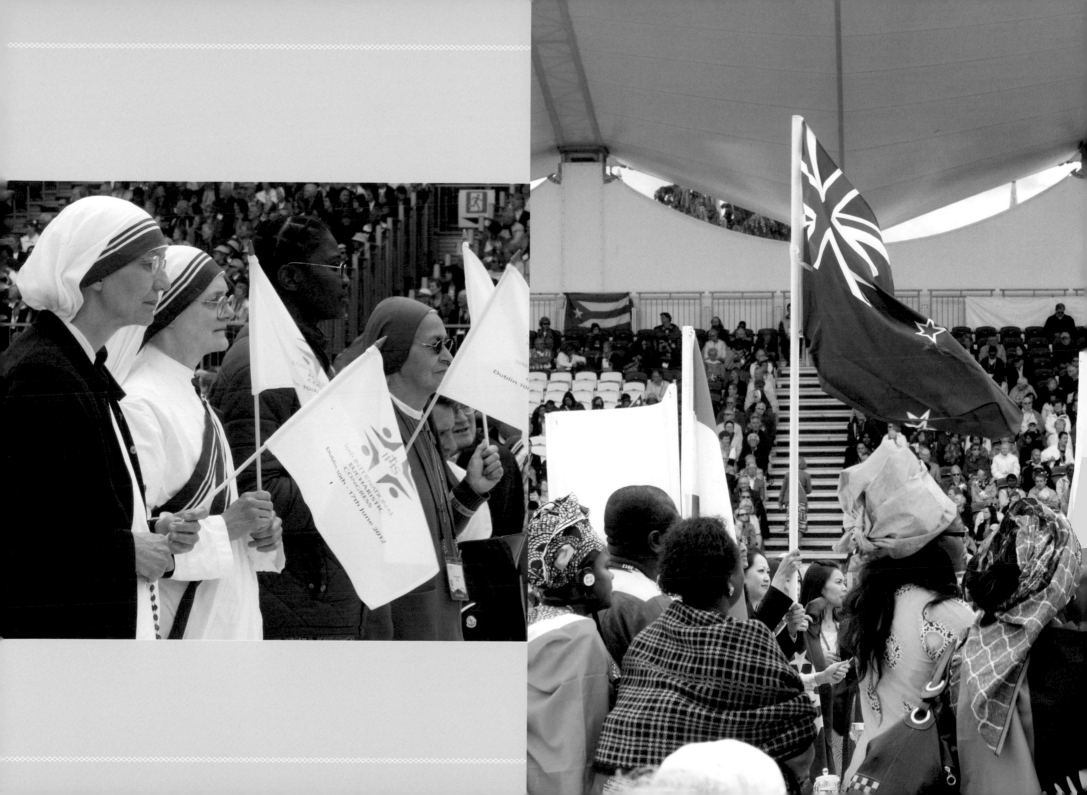

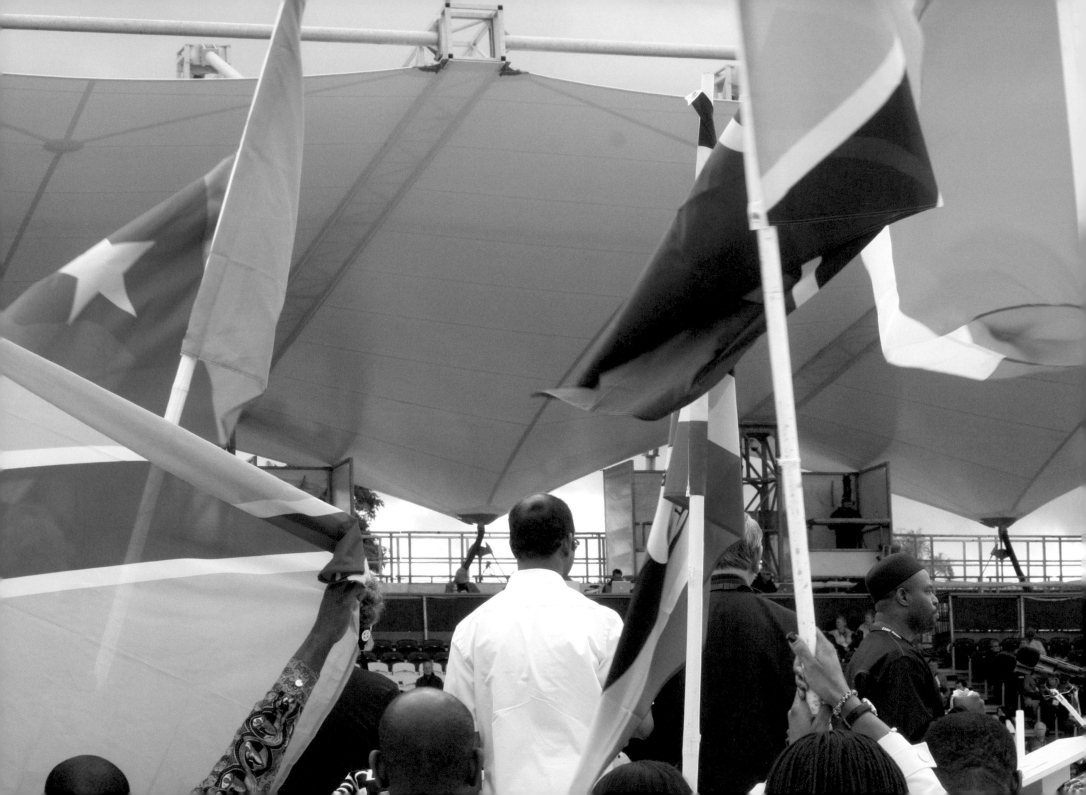

Glorious sunshine, an atmosphere of fiesta, huge diversity without division, a sense of celebration, many little sacraments of encounter and a fleeting glimpse and confirmation that we really are companions on the journey – all of these were my impressions of the first full day of the International Eucharistic Congress. This was the ecumenical day. The fact that it came first made a statement. It was a sign of hope and an encouragement to those of us from other branches of the Christian family that there is a new acceptance, respect and understanding beginning to take root among us, nurtured by a hard-earned humility as we struggle to truly be the Body of Christ in today's world. I was glad to be part of it.

REV. DR RUTH PATTERSON

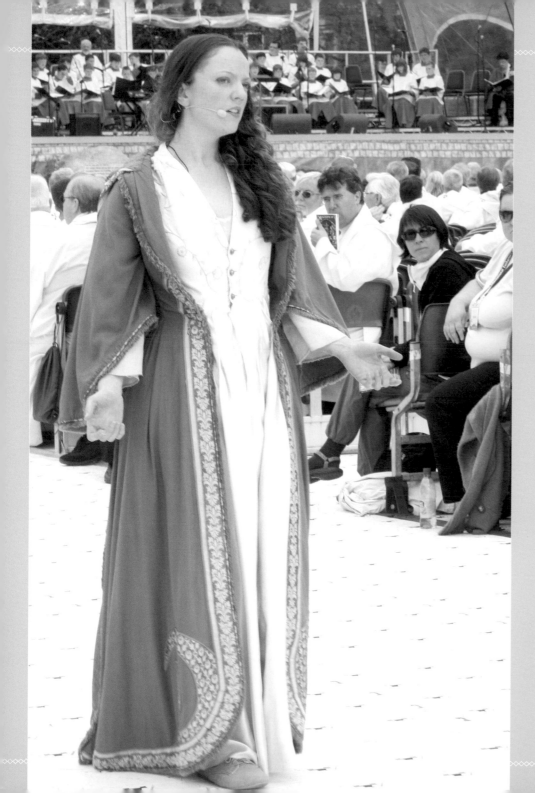

As a volunteer with IEC2012, I had the great job of interviewing attendees and sharing with the rest of the world what was happening in Dublin during the week. It gave me a wonderful opportunity to experience at first hand the joy that flowed abundantly, as well as documenting the rich mix of people from Ireland and the rest of the world, which highlighted the universality and vibrancy of the Church. Pope Benedict XVI said at the final Mass that: '[The theme] leads us to reflect upon the Church as a mystery of fellowship with the Lord and with all the members of his body.' And this too provides the explanation of the great success. At the centre of the Congress was the Eucharist, and it is from Jesus himself that ultimately all unity comes. From and through communion with Christ, the encounter and friendship with the living God, we enter into true communion with one another. It is exactly this encounter which resulted during the week in a great atmosphere.

For me, it was a week of meeting new and old, from close and far away. It was a week of joy and excitement, but mostly of a renewed experience of the unity with the people I met, which only comes from a closeness and unity though Jesus. This experience will continue to foster unity and joy in times to come and has sown a lot of seeds which will continue to blossom. We are now called to share this joy with others around us.

LUUK DOMINIEK JANSEN OP

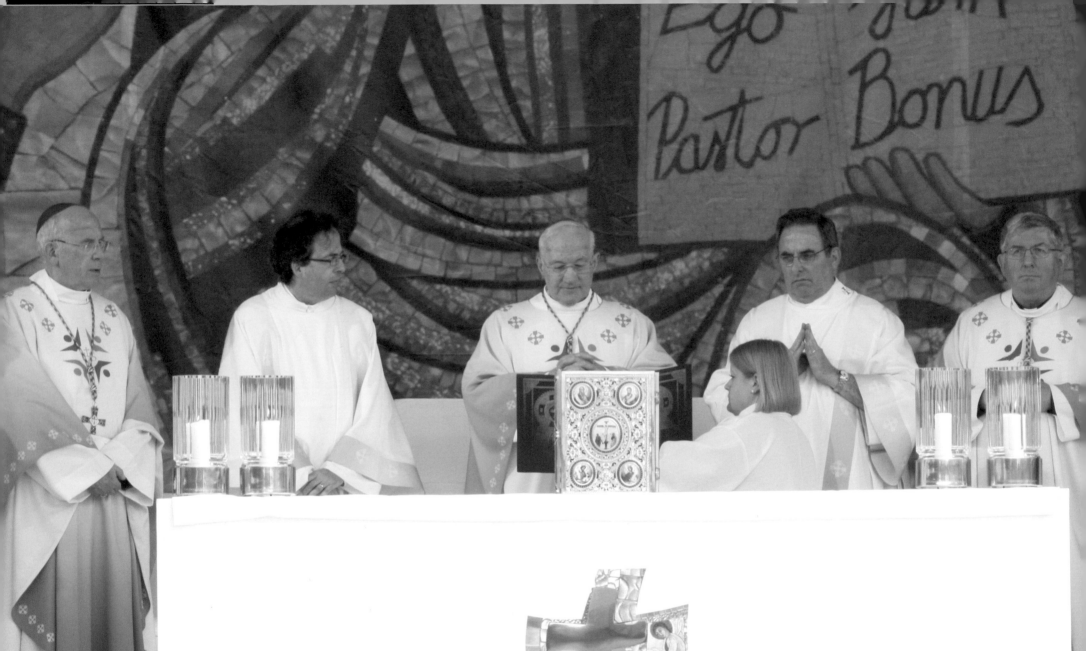

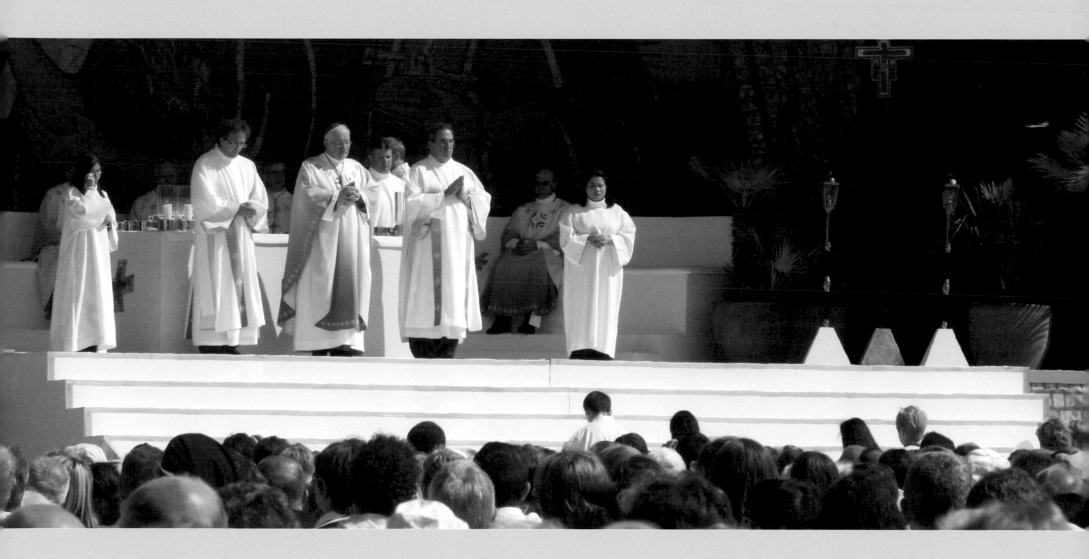

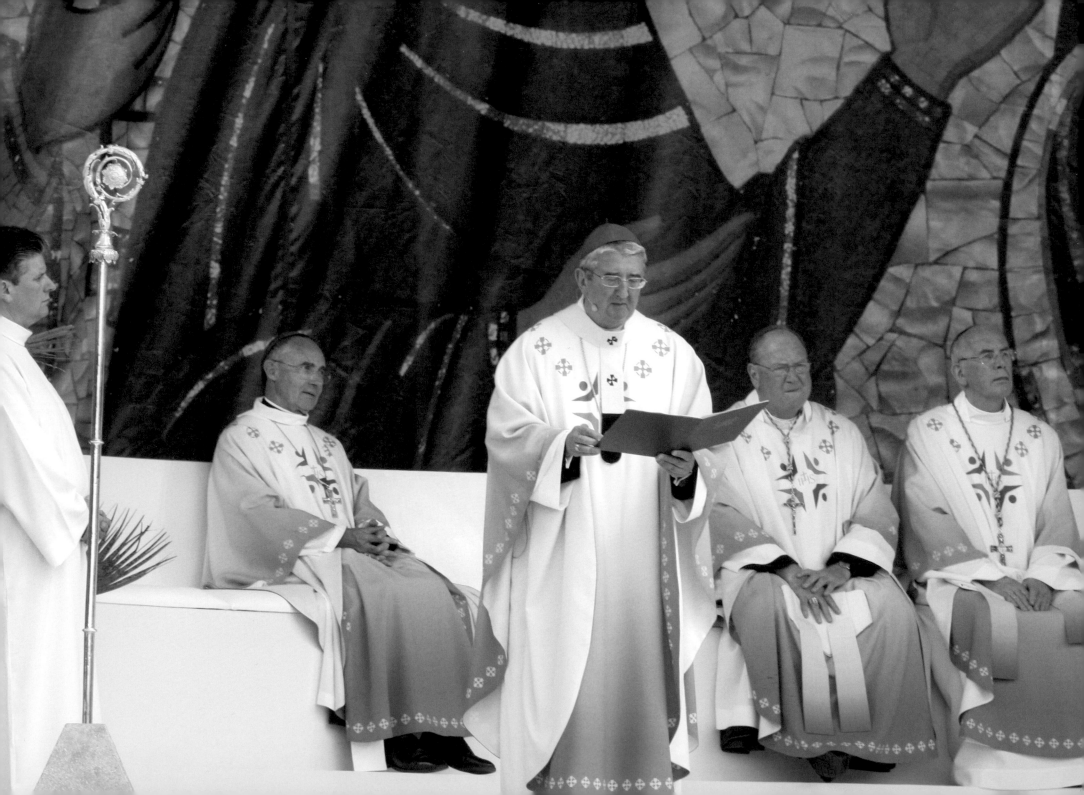

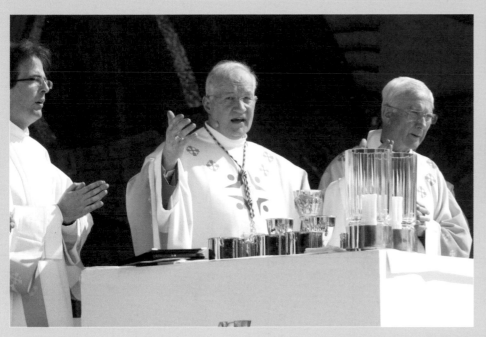

I believe that the Eucharistic Congress marked a turning point for the Irish Church. It was uplifting to be part of such a positive celebration of faith. I also feel that the Catholic Grandparents Association, being asked to speak at the Congress, marked the coming of age for our organisation. It showed that the Church, at the highest level, is starting to recognise the vital role grandparents have to play in passing on the faith. I was overwhelmed by the reception from people of all nations attending our workshops. People from all over the world came, and everybody wanted to know more about us. The international nature of the Congress was especially inspirational for me. It helped me truly see how our Church transcends time and place. Above all, the Congress left me with a powerful sense of hope. I saw at the Congress that no matter how dark the night, there is always dawn.

CATHERINE WILEY

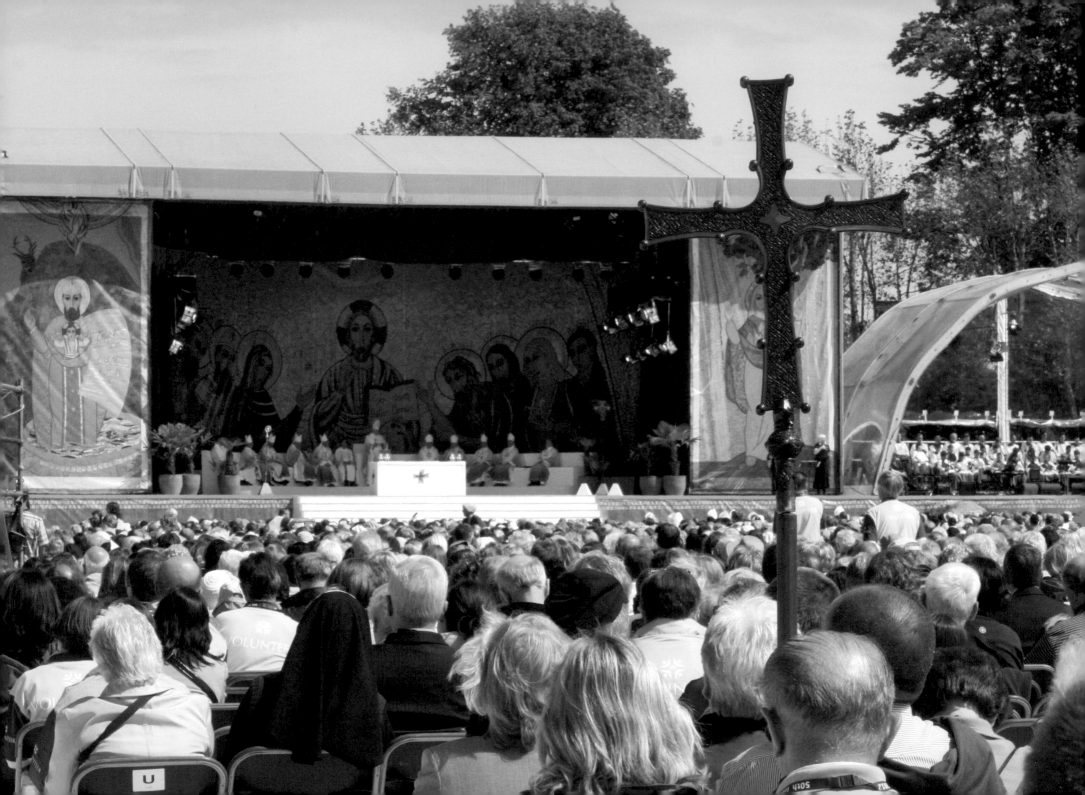

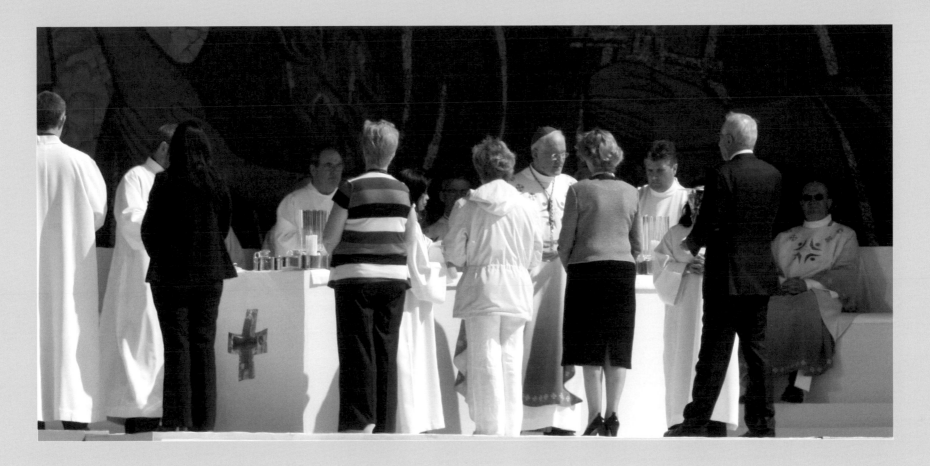

Possibilities. That encapsulates my experience of IEC2012. I was involved in the schools-related preparation for the Congress, and attended some of the Congress week events as a member of the Share the Good News Implementation Committee. In anticipation of IEC2012 both at school and parish pastoral council level, I witnessed the willingness and hunger of the faithful to gather, listen, be nourished and go. I hope that we will retain this renewed and nourished sense of mission and look forward to future events that will build upon the treasures of IEC2012.

BERNADETTE SWEETMAN

Being a volunteer at the 50th International Eucharistic Congress was an amazing, once-in-a-lifetime experience. I was assigned the role of assistant stage manager for the opening and closing ceremonies. This meant that I had the opportunity to meet many of the people participating in these events, including bishops, priests, musicians and choirs, as well as pilgrims from Ireland and abroad. The highlight for me was the way everyone shared a sense of joy and unity as we worked together to celebrate and share our faith. It was a truly uplifting event.

AILÍS TRAVERS

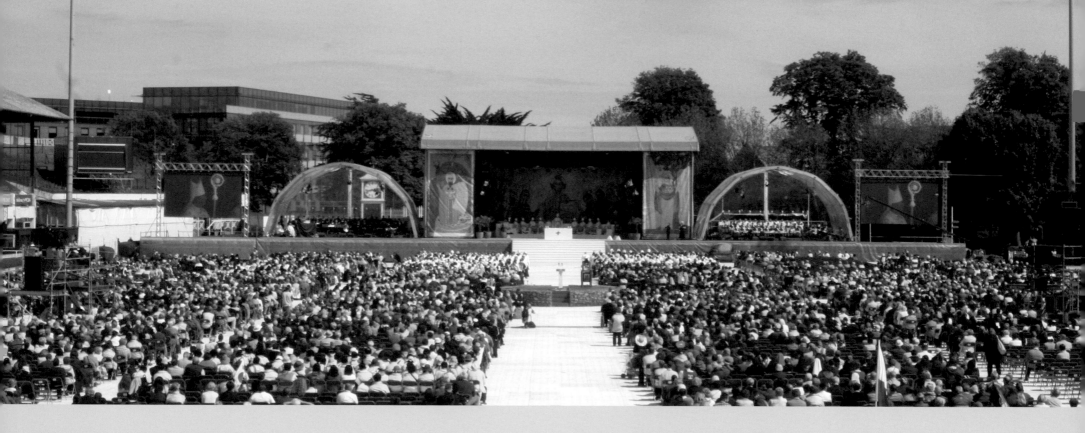

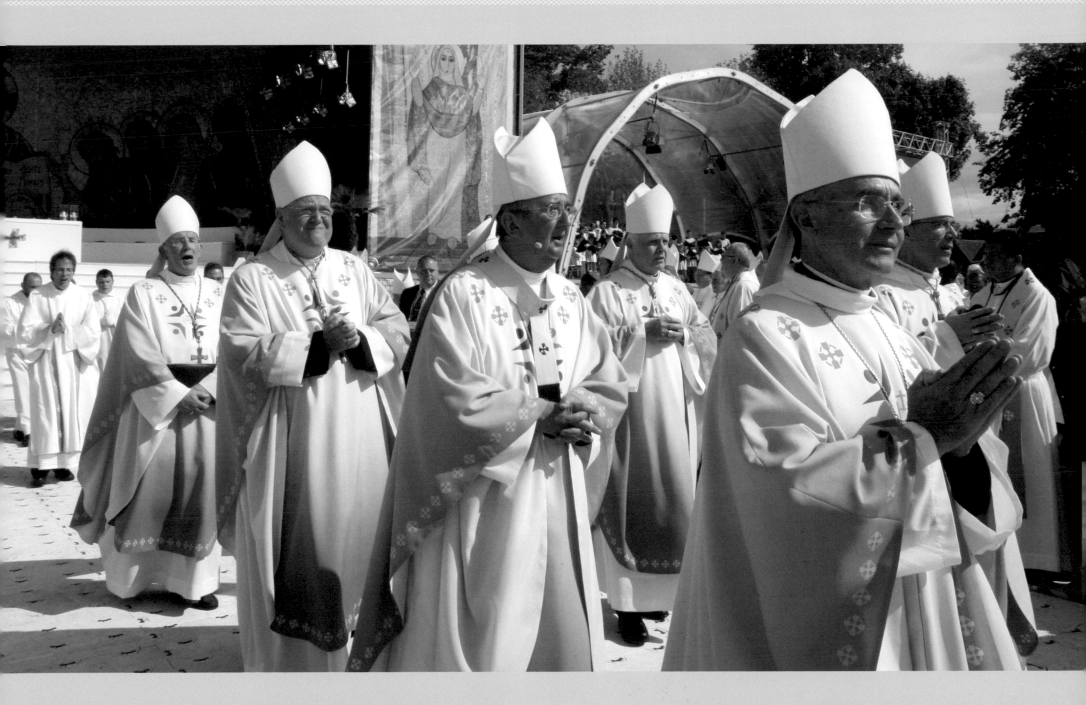

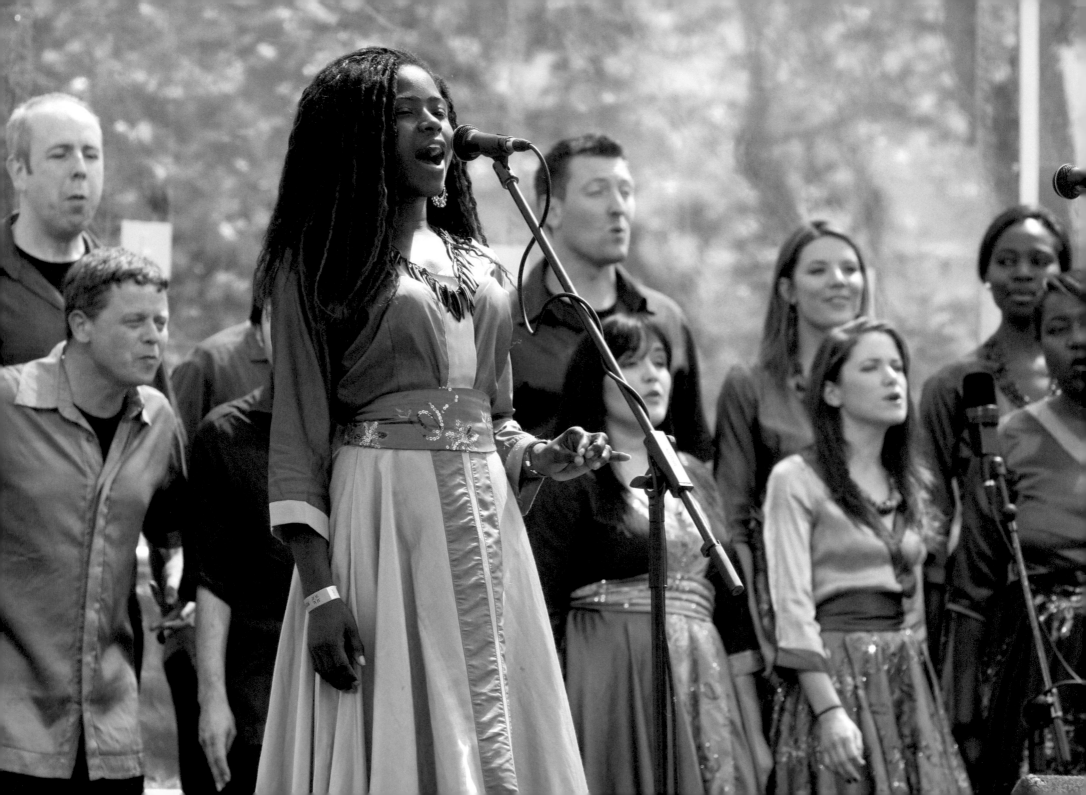

An invitation to speak at an International Eucharistic Congress in your own country is probably a once-in-a-lifetime opportunity. The reality of presenting a workshop in such a unique environment was daunting, exciting, affirming and humbling. Leaving my workshop, I experienced what was to become, for me, the resounding memory and enduring challenge of the whole event. Outside were so many people, including my own mother, who couldn't get in because there was no room. This experience was repeated over and over again every day. What will remain with me for a very long time is the sight of so many people queuing for hours to be fed, nourished and nurtured in their faith. The challenge now for the Irish Church is to fulfil the command of Jesus, 'feed my sheep'.

MAEVE MAHON

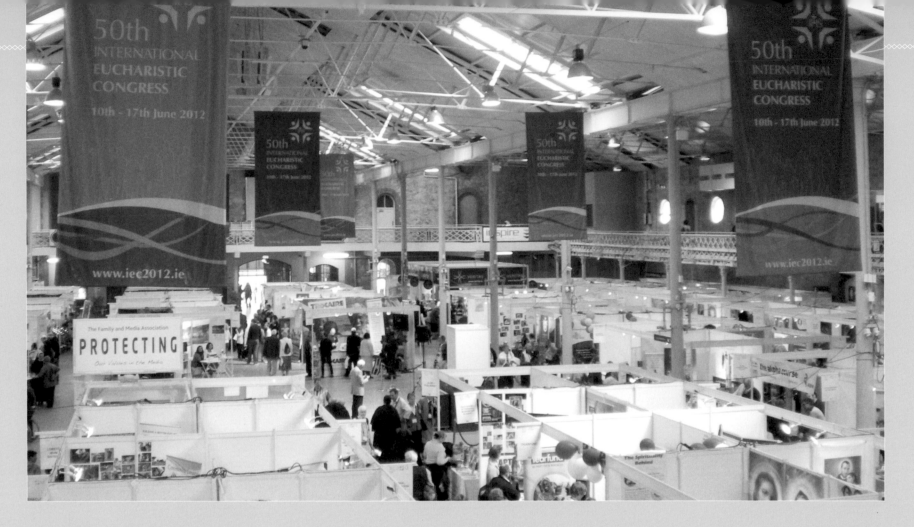

My abiding memory of the 50th International Eucharistic Congress is the 'village atmosphere' that I experienced at the RDS during the week. Drifting around from venue to venue and stall to stall in the Exhibition room, people from all aspects of the Catholic community met and mixed with each other. Young people from Ireland and abroad mixed with their 'elders', whom they would not normally meet. Well-known names, cardinals, master generals of orders and prominent lay people were often found talking casually to people whom they had never met before. All shades of opinion from across the Catholic spectrum also had an opportunity to meet and speak. God's Holy Spirit was in the place, and the fear that so often still keeps disciples behind closed doors, evaporated under his breath. The celebration of the Eucharist became a true celebration of communion, with Christ and with one another.

BISHOP JOHN FLEMING

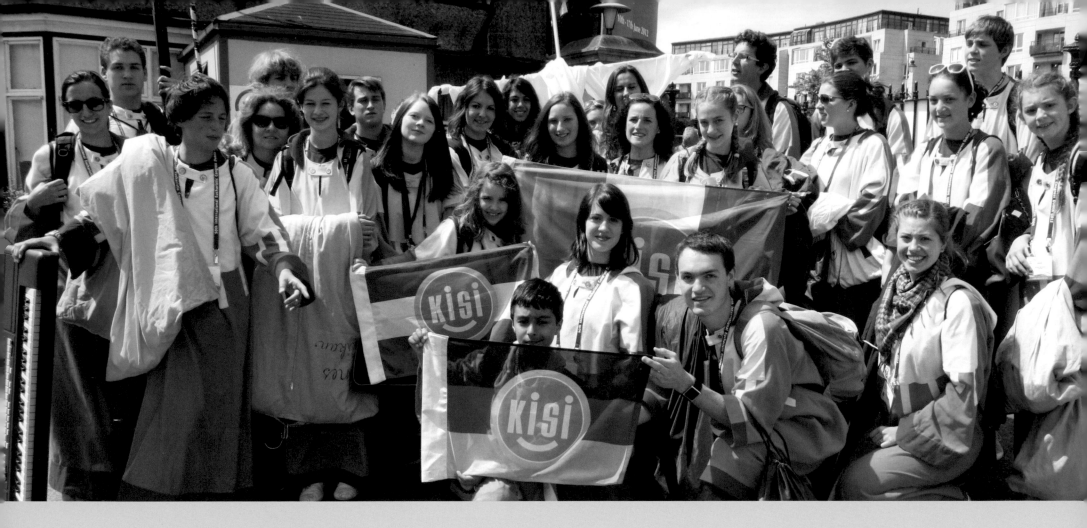

'Me? Speak at the Eucharistic Congress on the topic of marriage? You must be joking! I'm no theologian.' 'We're not looking for a theologian. We want an experiential account. You have broadcast and written about this subject.' 'Well, that's the only way I'll do it – as another "Letter to Olive".' Tuesday, 12 June 2012, Hall 3, RDS. There must be nearly a thousand people here. What have I let myself in for? In the audience I see a group from Ballivor, my native village. That lifts the heart. I give it my all, straight and true, for twenty minutes. A standing ovation follows. I am truly overwhelmed and humbled. I spend the next three hours signing books at the Veritas stand, receiving thanks and congratulations. One of the most privileged days of my life.

JOHN QUINN

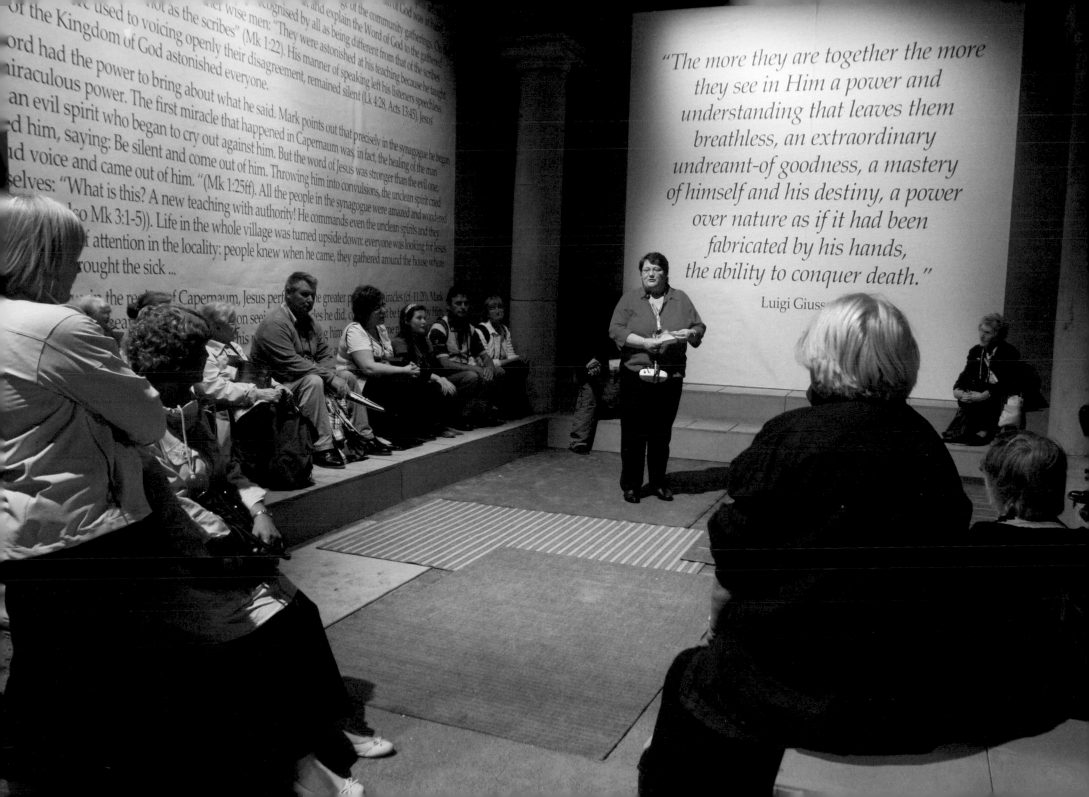

We in Radharc Films were very pleased to be asked to participate in the Eucharist Congress in Dublin in June 2012. Our contribution was to show some of the films from the Radharc archive of documentary films. Radharc was a film company of priests and laypeople who made films for Irish television on religious, social and cultural issues from 1962 to 1996. Altogether over 400 films were made in seventy-five countries during that period.

The films screened at the Congress were as follows: *The Congress of 1932* – a silent film from that time with a voice-over of memories of some of those who attended; *A Congress in the Likeness of Pope John* – looking back twenty-five years later and asking what had happened to the vision of Pope John II; *The French Connection* – a film exploring the emigration of many Irish in the 1800s to Canada, and how they became as French as the French Canadians themselves (indeed, one of their number, Brian Mulroney, became Prime Minister of Canada); *Kitty's Folly* – the life story of Catherine McCauley, a wealthy heiress, who founded the Sisters of Mercy, which became the second largest order of Sisters in the world. All the films were screened to packed houses and the film on the Congress of 1932 had to be shown a second time, such was the demand to see it.

PETER DUNN

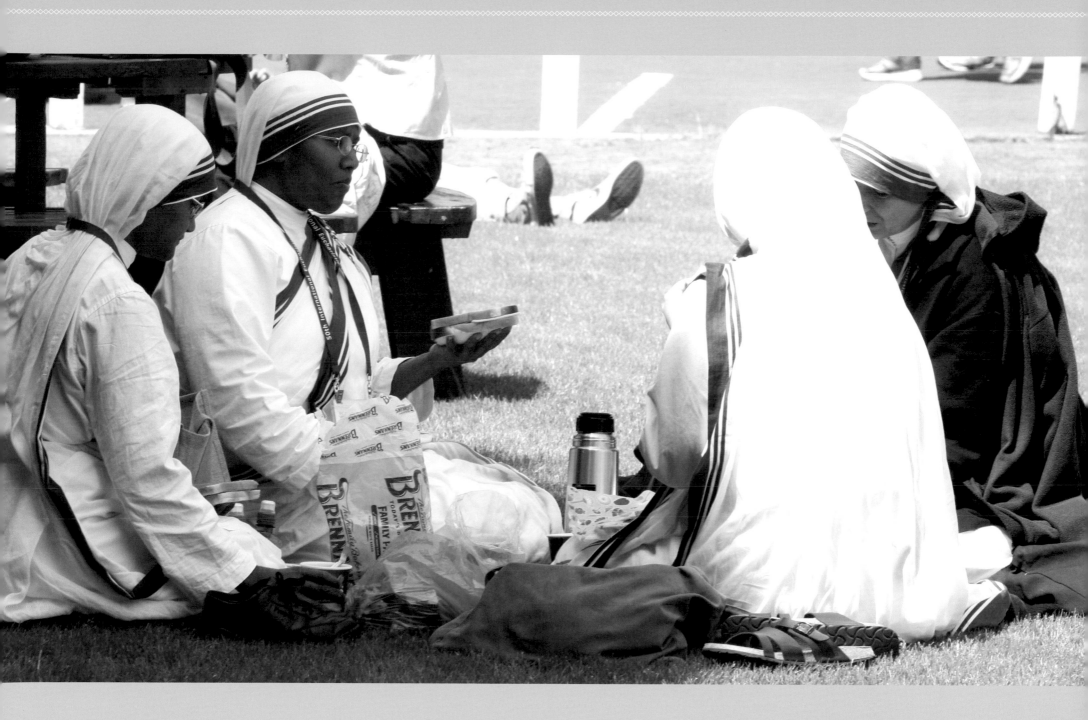

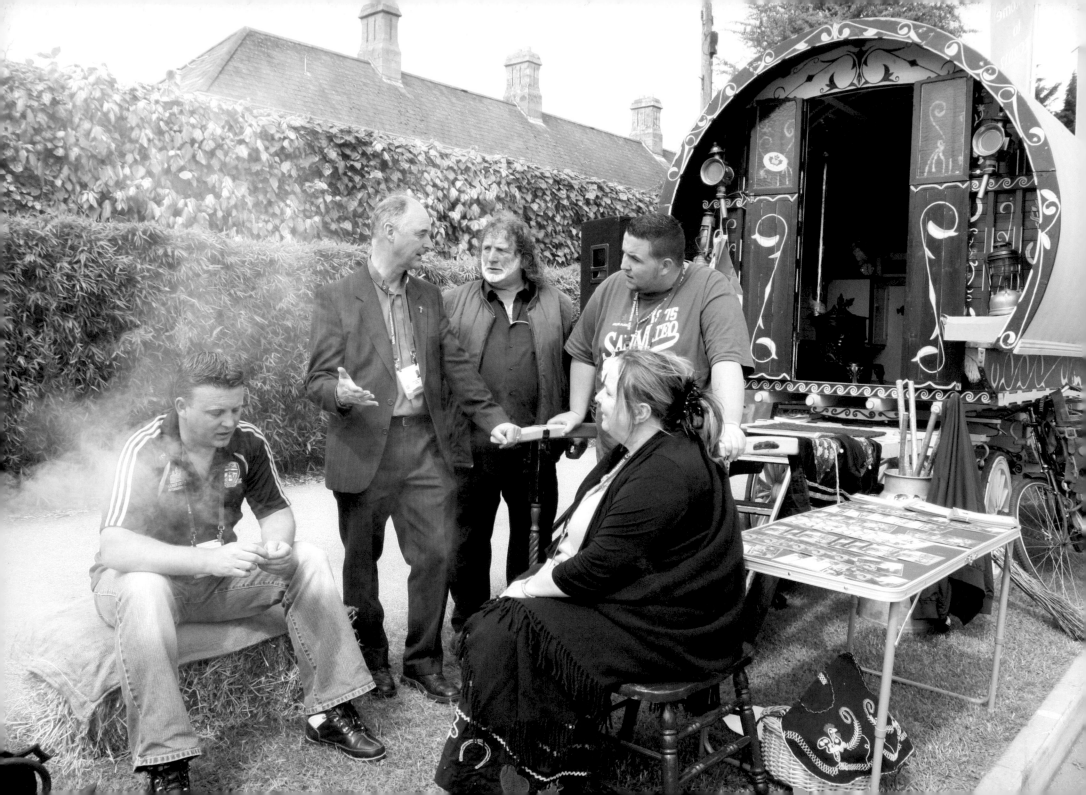

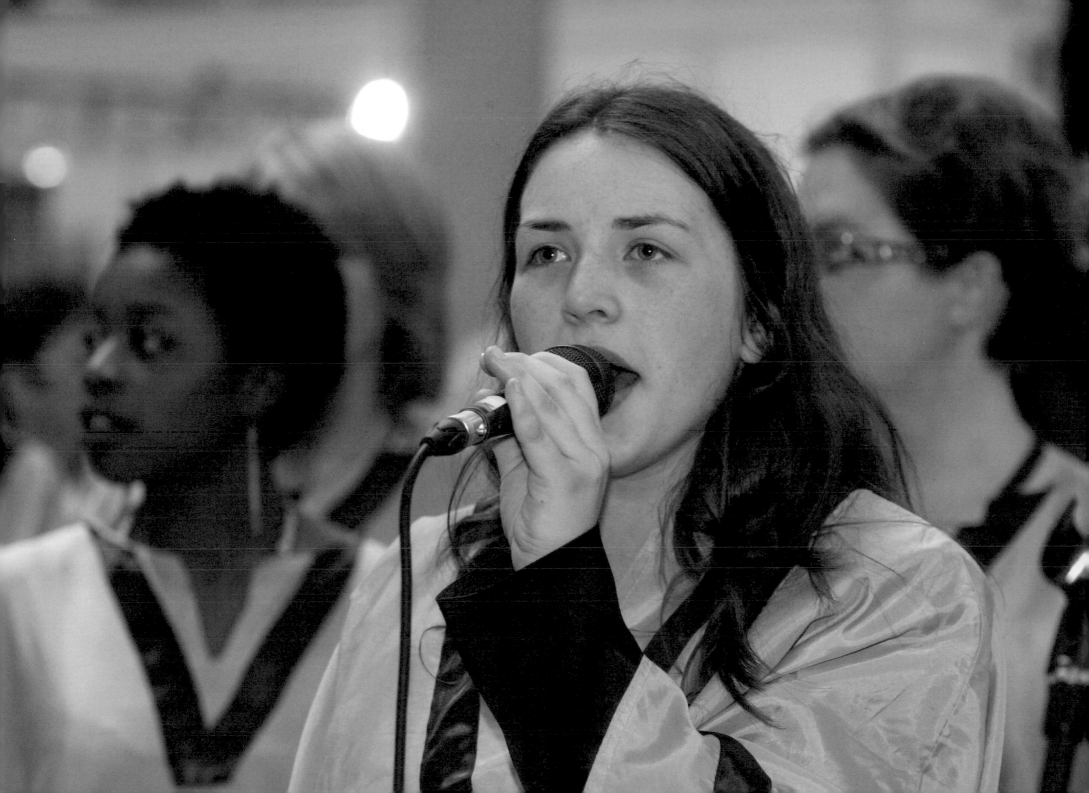

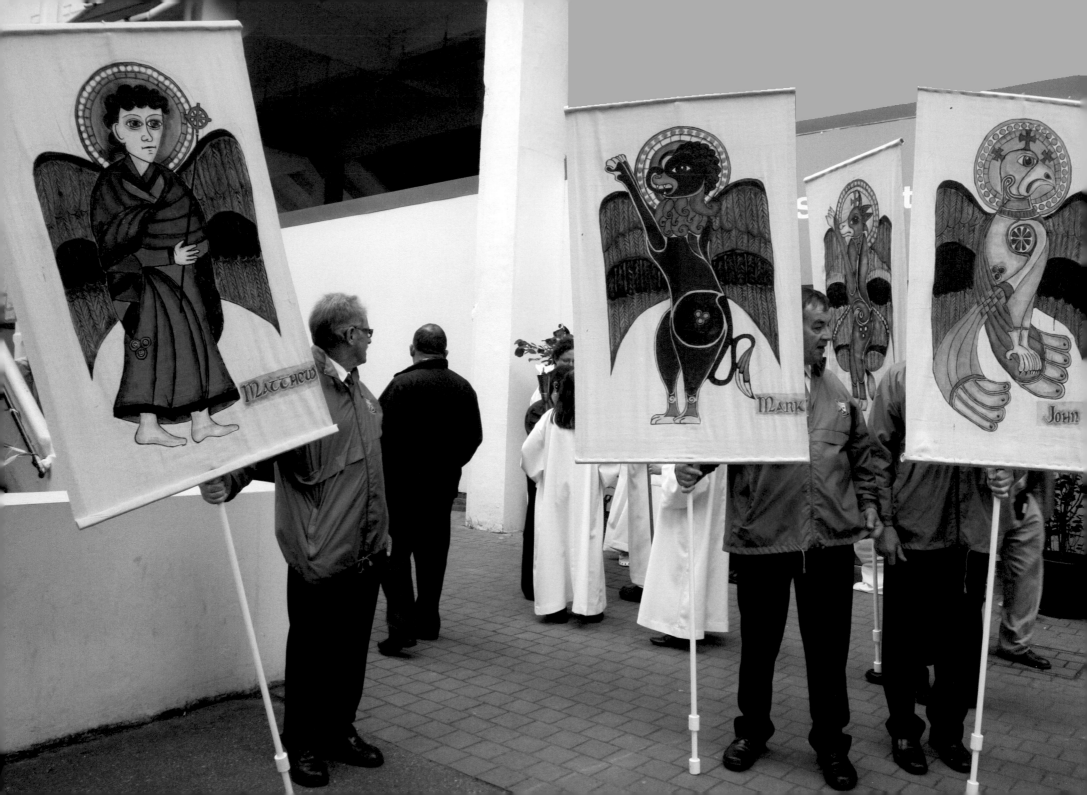

The most striking thing about the 50th International Eucharistic Congress in Dublin was the way it showed how the Mystery operates beyond and around the logic of the world we think we know. For me, the most striking thing was how the energy of those of us who attended took each one of us by surprise, and therefore drew from us a degree of passionate engagement that grew through the week. As the days passed, we learned that although the passion of Irish Catholics for Christ and Christ's proposal had been pushed out of common view in our culture, it remains strong underneath, in spite of everything. Overall, it was a week of immense celebration for Irish Catholics, who for once could stand up with pride and conduct the conversation they longed to have, in a place where they had the freedom to conduct them. The intensity all week was deeply striking – not a 'charismatic' intensity, but something that suggested a more 'alive' kind of human existence and outlook, something I had not encountered in Ireland for a very long time. In the looks on people's faces, in the way they greeted and spoke to one another, there emerged a kind of unspoken statement – not just 'I am not alone', but 'I have not been alone after all'.

JOHN WATERS

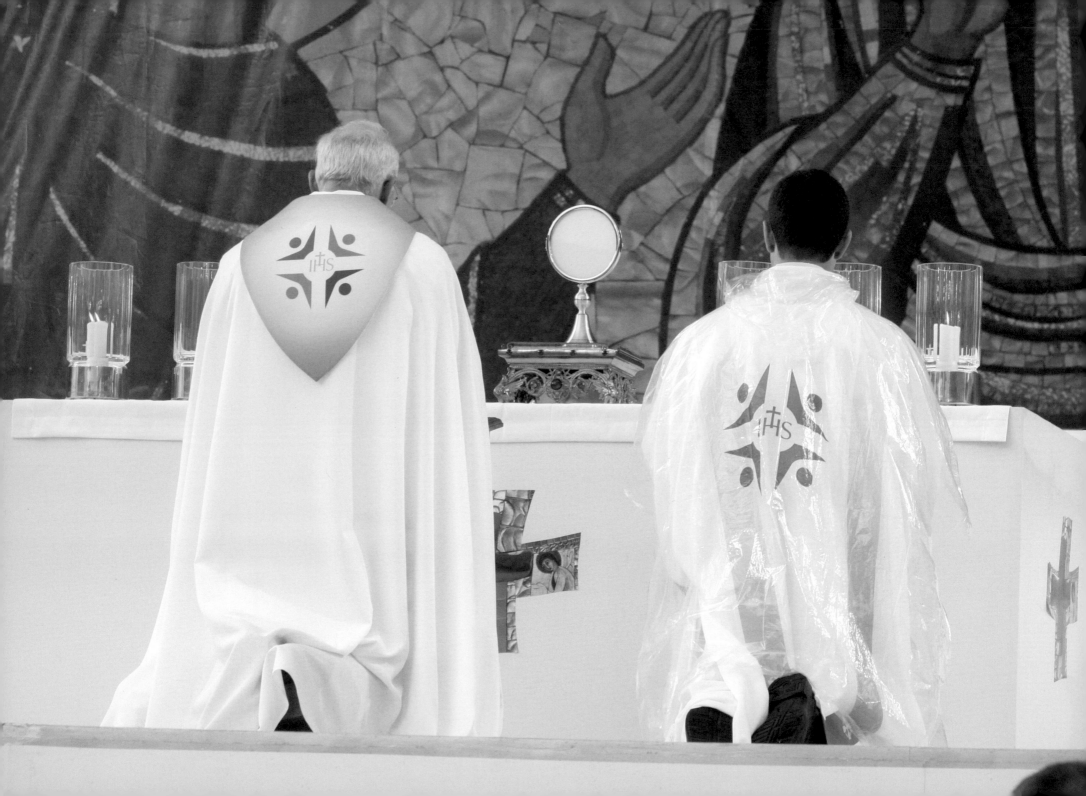

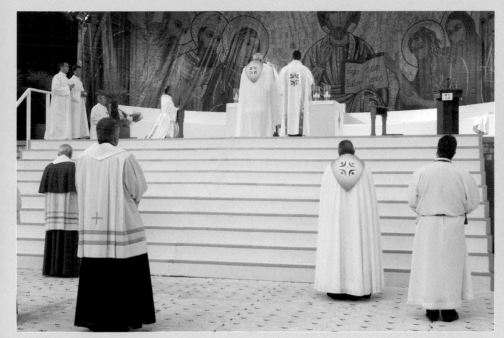 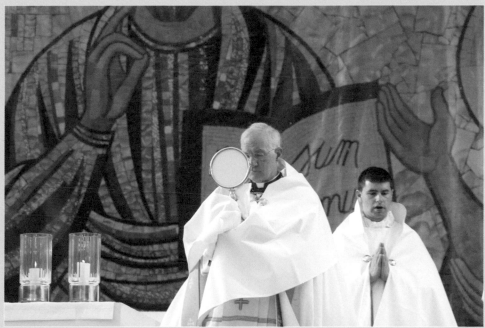

The great thing for me about the Congress was – and still is – the contribution of RTÉ. Eileen Dunne and Joe Duffy were superb hosts at the final Mass in Croke Park. They just drew me in to all that was happening. Being ninety-one – and incidentally having been around for the 1932 Congress – I was not able to be physically present at many of the events. My joy, then, is to sit at my laptop and make a spiritual communion as often as I switch on the RTÉ player.

FR GABRIEL HARTY

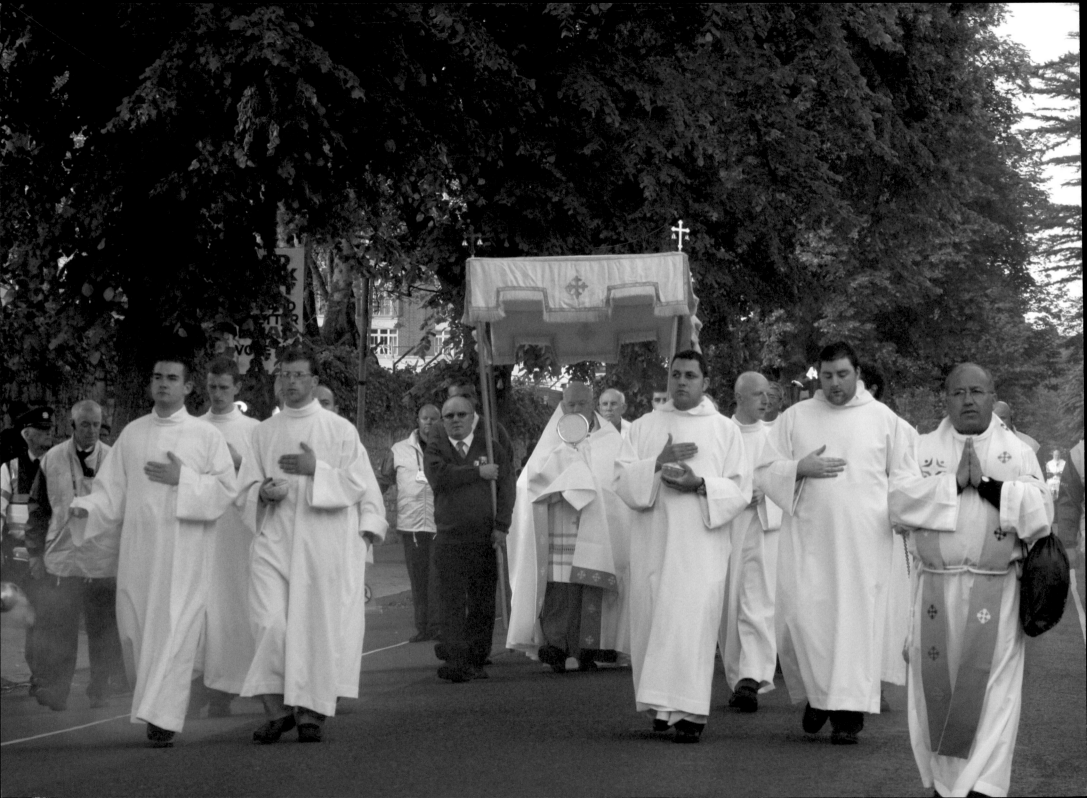

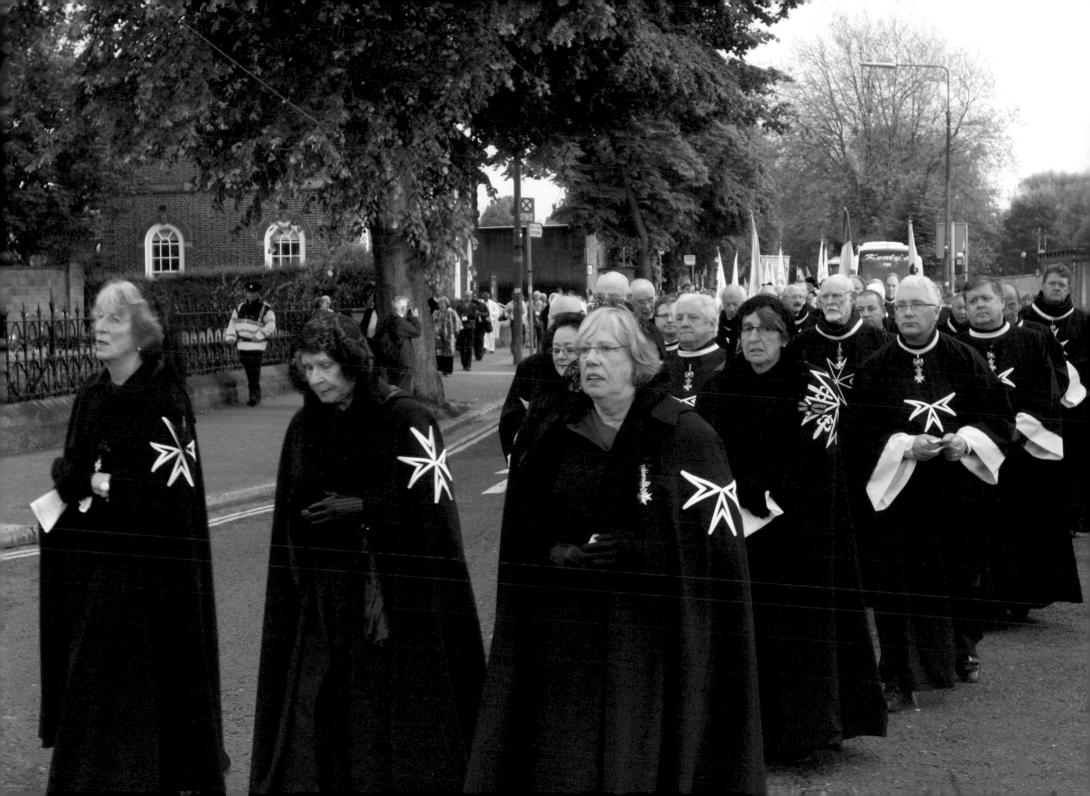

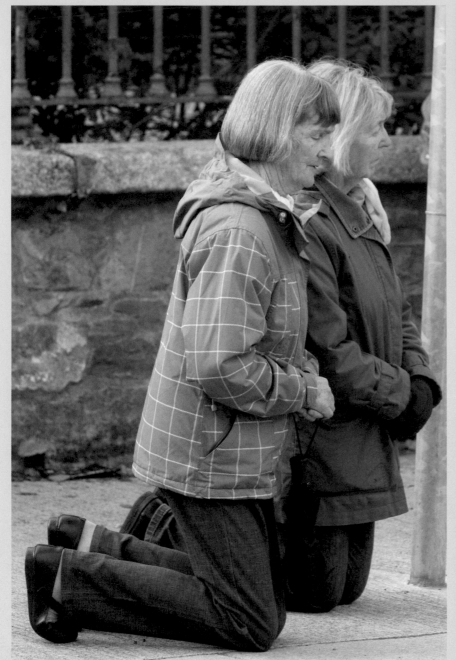

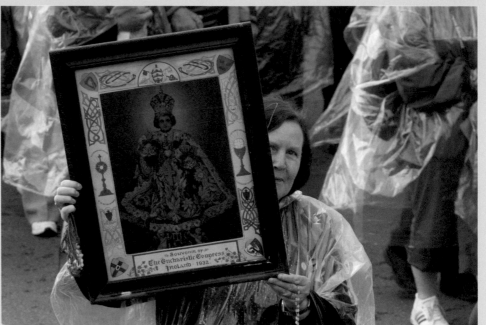

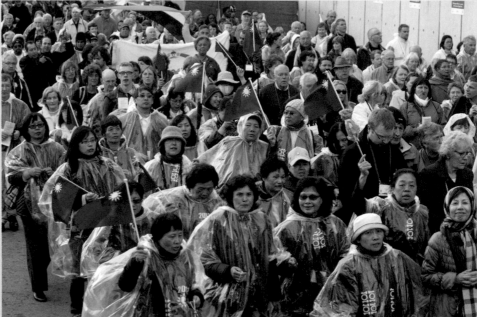

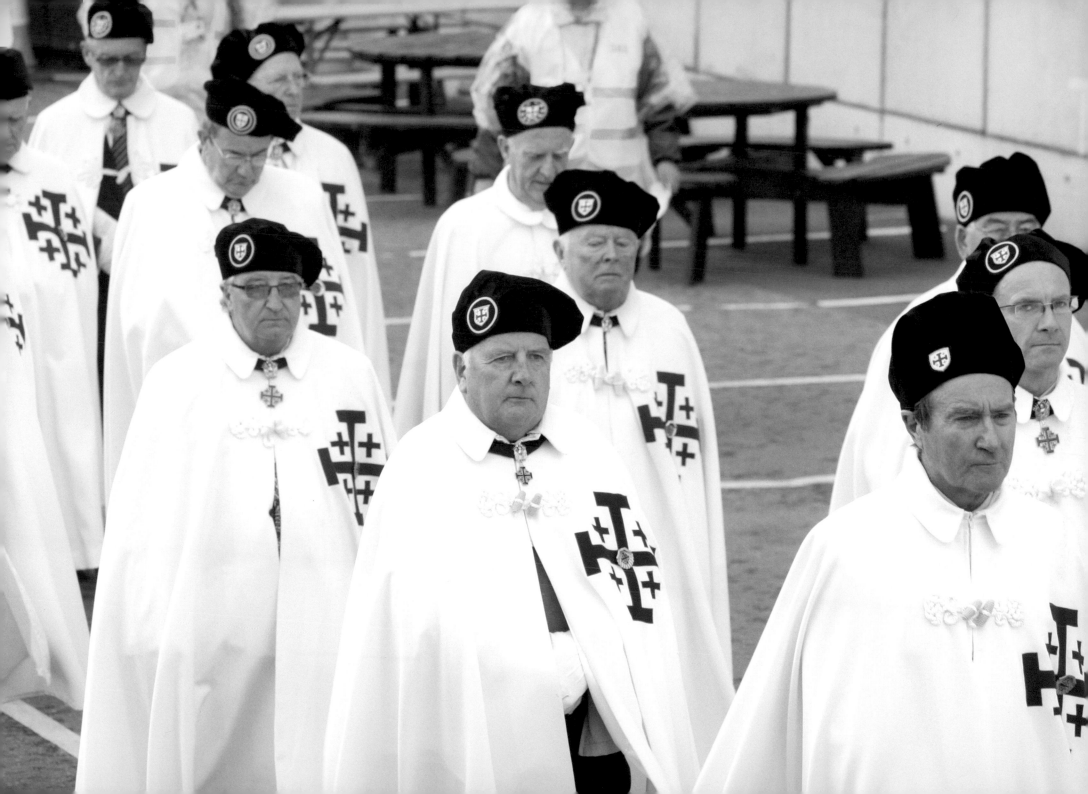

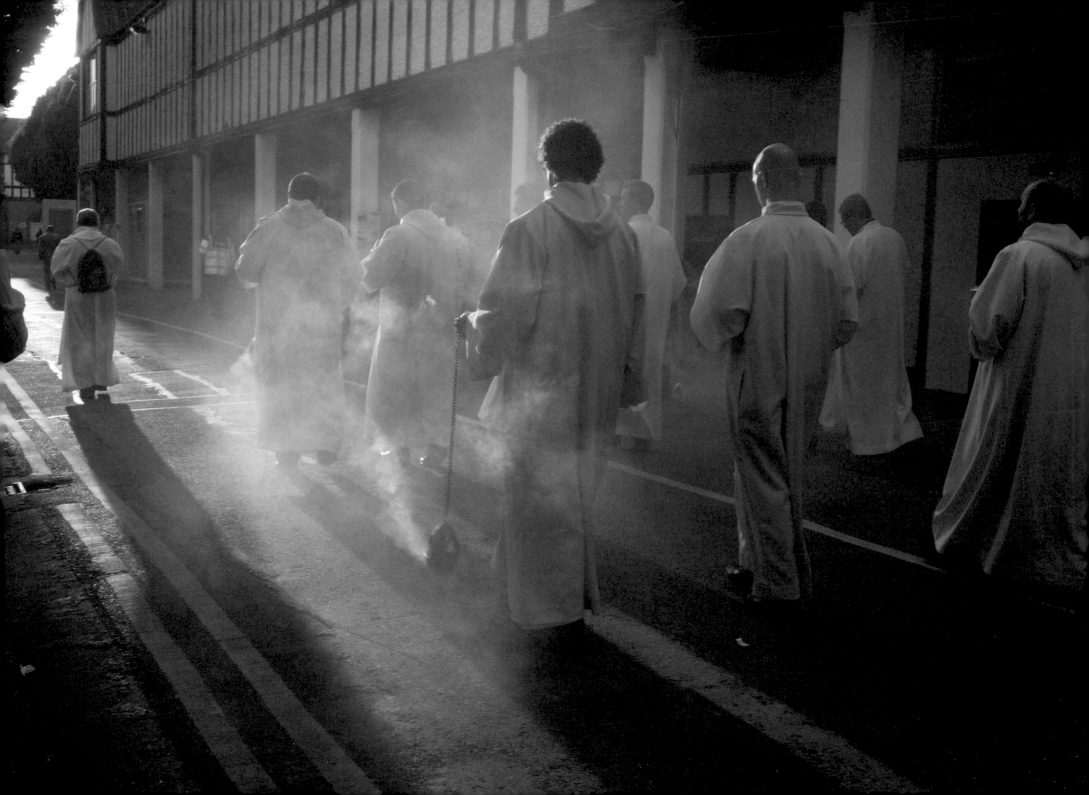

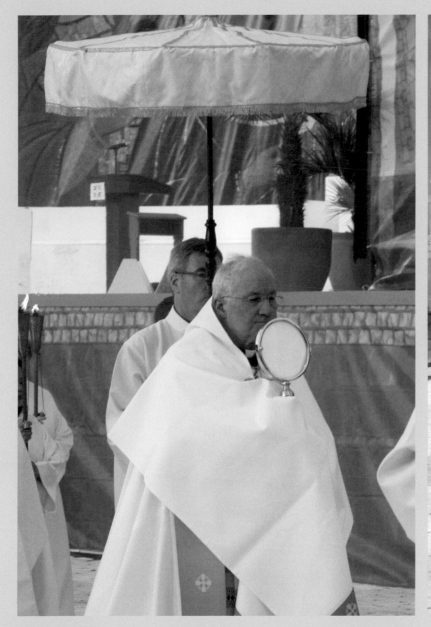

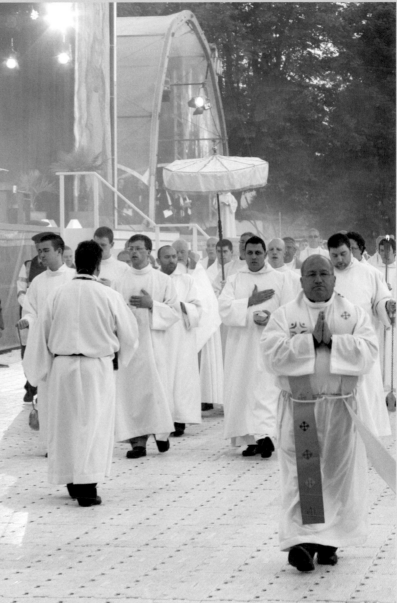

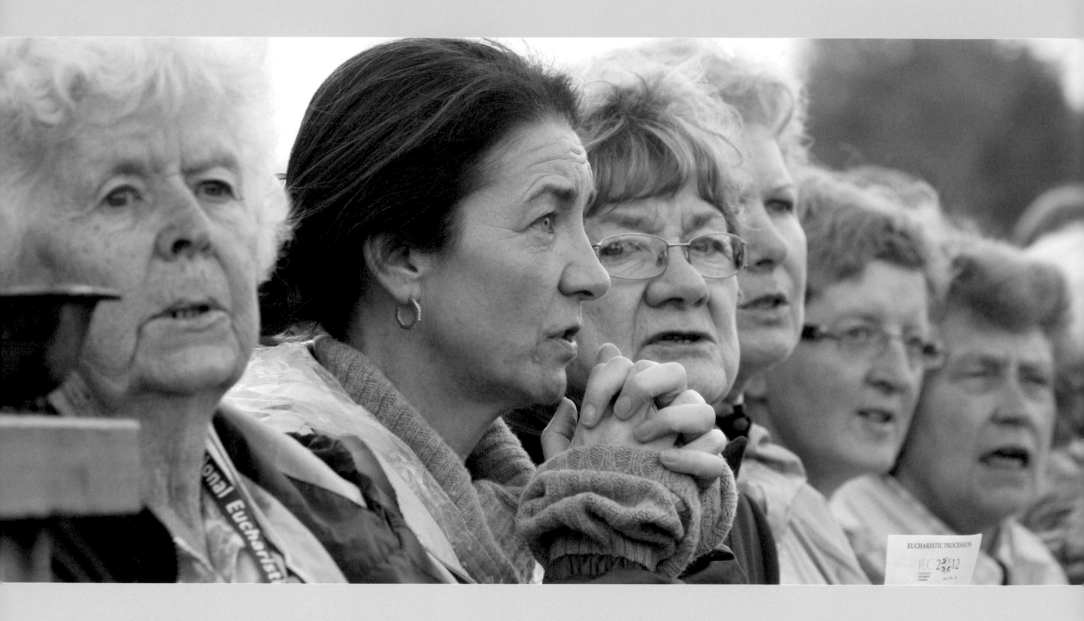

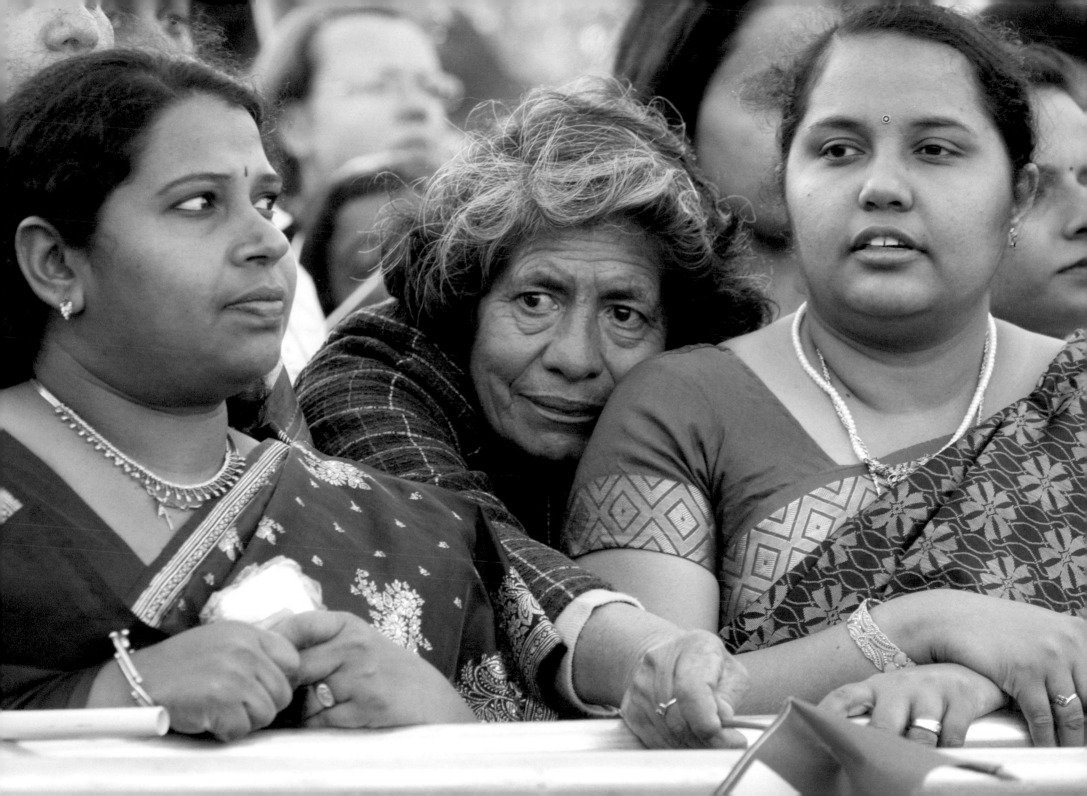

Like many people, I suspect, I was unsure how the Eucharistic Congress of 2012 in Dublin would be received or, indeed, attended, and given the last number of years of deep crisis for the Irish Church, whether the timing was right. As the Congress approached, therefore, I did not know exactly what to expect.

I attended the Congress on two separate days: the RDS on the Wednesday and the Closing Mass in Croke Park on the Sunday. It was the experience at the RDS that struck me most. Although I only managed to attend one talk, I spent much of my time exploring the Exhibitions Hall. And it was here that the panoply of Irish Catholic life could best be sampled: from Pax Christi to Pure in Heart; from the Dead Theologians Society to offers to tour Christian Carlow; Cuan Mhuire met the Catholic Grandparents Association and Trócaire encountered EWTN; the Legion of Mary and Alpha International also shared one big room (all of this with echoes of Isaiah 11:6!). And the adherents of all these groups (and scores of others), who might rarely meet under the broad banner of Catholicism, were gathered together into this one, large and celebratory tent. For, despite the law of minimal differences, which tends to drive many Catholics into deeply entrenched splinter groups, for this one glorious week we were reminded that there's something bigger than what our pigeon-holing tendencies often suggest – that Catholicism at its best is a big and welcoming tent which gathers all hues together as one; in communion with Christ, yes, but also, crucially, inviting us to be in communion with one another.

SALVADOR RYAN

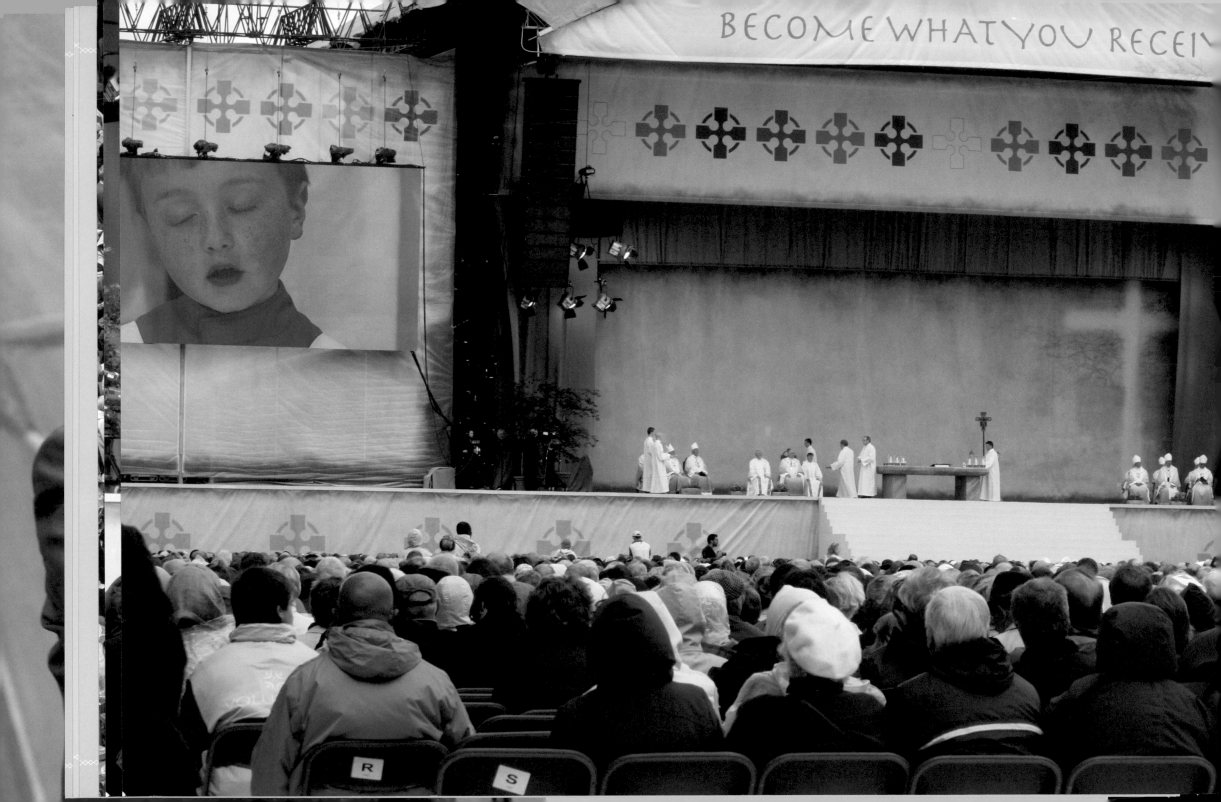

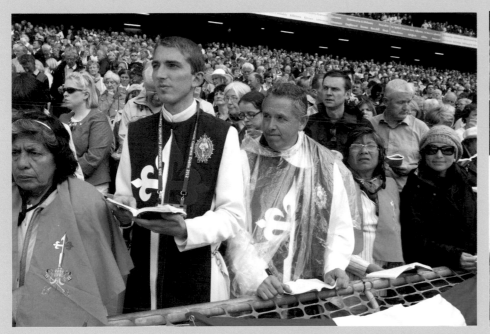
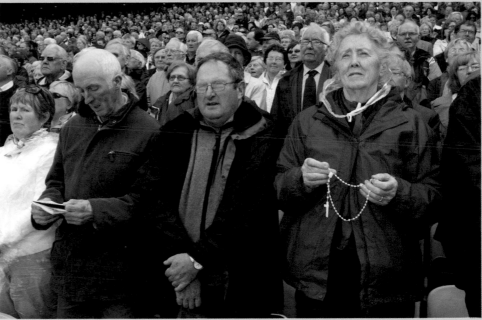

The early work with other members of the theology commission on drafting the Theological and Pastoral Reflections document was the beginning of the Congress for me. It was followed by a collaborative experience of preparation in Maynooth for the International Theology Symposium to be held there just before the Congress. Once the Symposium began, however, I could feel something great was overtaking us – there was such enthusiasm and joy, commitment and exchange, despite awful rain! But all of that was only the lead-up to the actual Congress experience. Entering the RDS (likewise Croke Park), seeing alongside one another in harmony young novices and happy bishops, eager participants queuing for workshops and busy traders, smiling volunteers and contemplative pray-ers, I felt it was like contemplating a living icon of the Church-city, Church-family, Church-people, Church-society. Young and old, international and lively. A moving highlight was the unprecedented time dedicated to ecumenism at the Congress involving Archbishop Michael Jackson, Dr Maria Voce of Focolare and Brother Alois, the Prior of Taizé. Immense gratitude remains in my heart for the many relationships built up before and during the Congress – such as in the workshops on the movements and on the dialogue of life – but above all, for the renewed passion for the Church which it enkindled.

BRENDÁN LEAHY

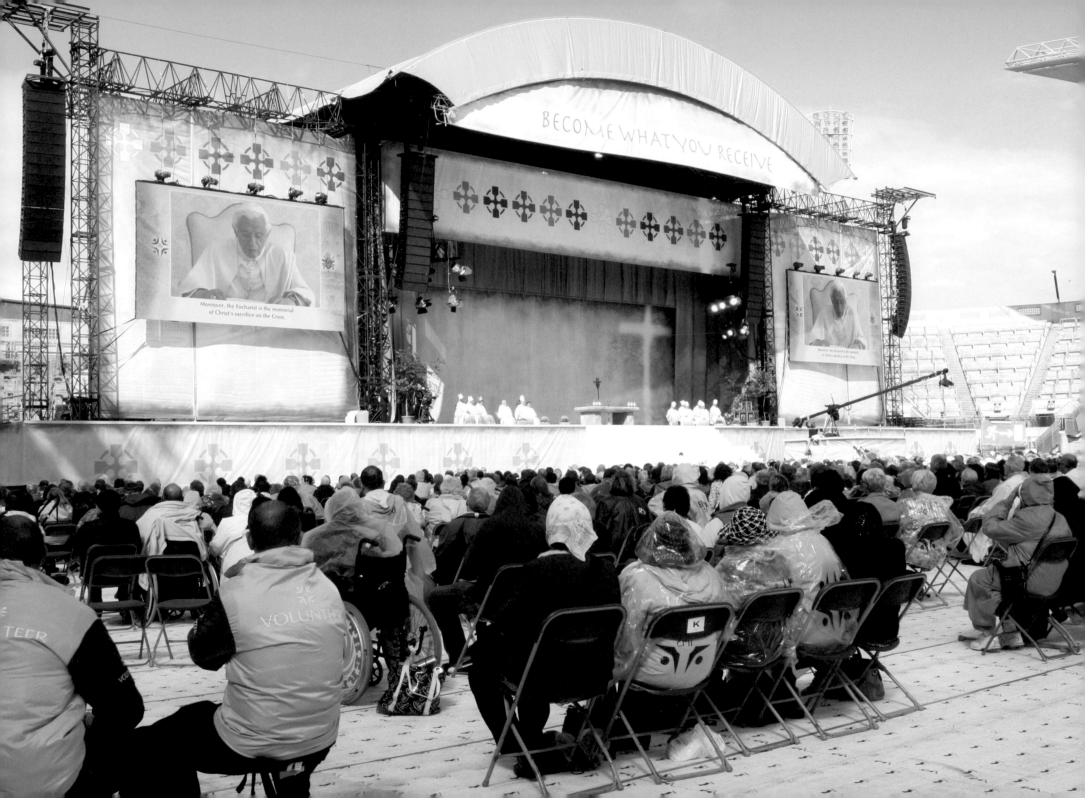

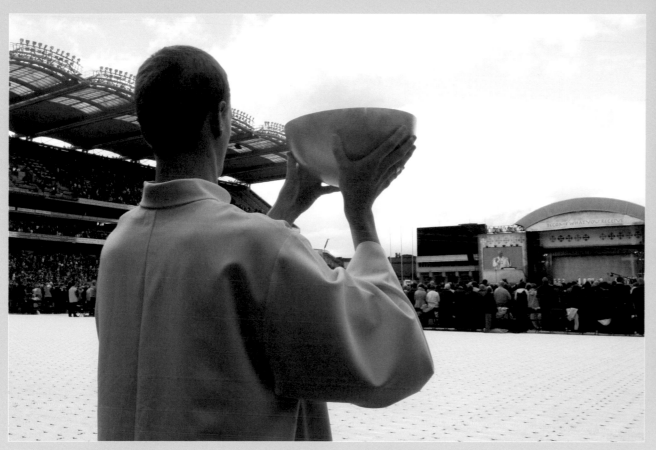

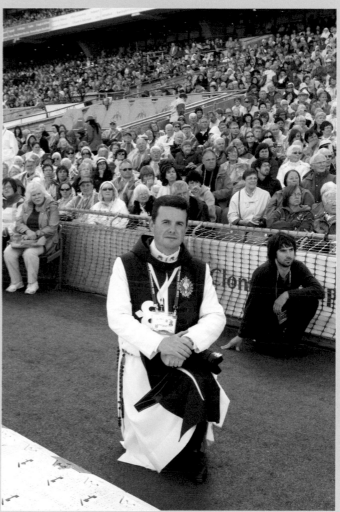

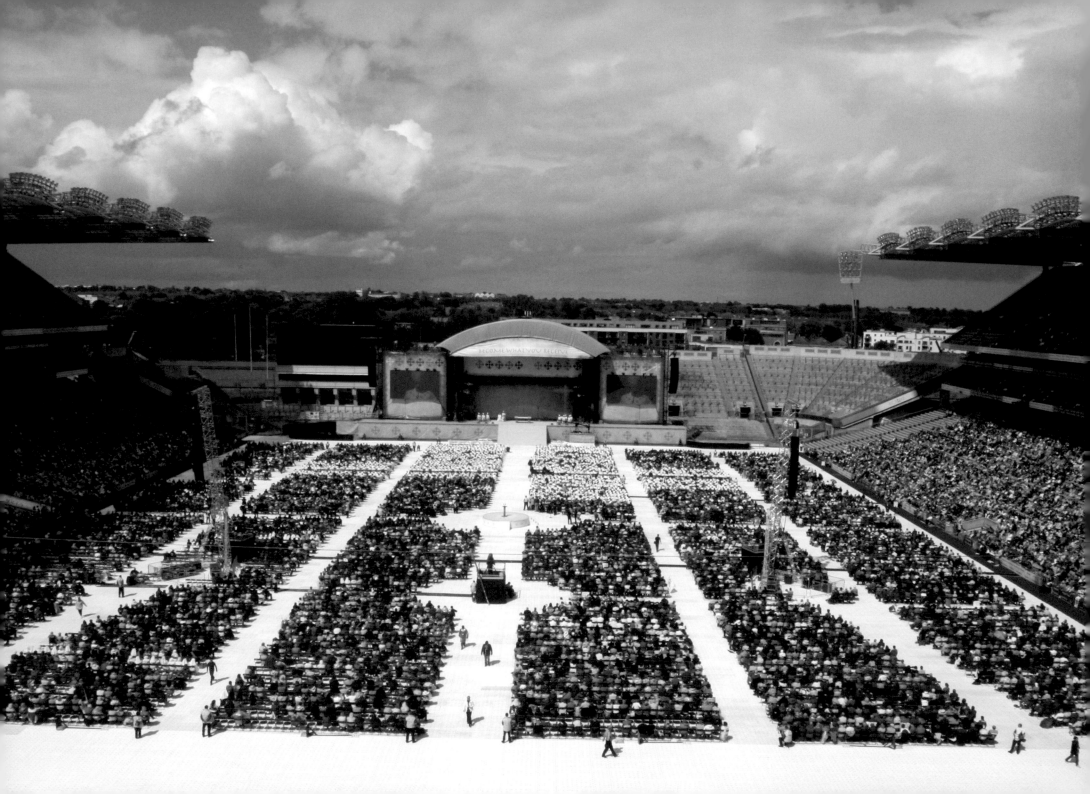

GRATITUDE (*EUKHARISTIA*)

For the three years of preparatory meetings – *Eukharistia*!
For raising funds, spirits and volunteers – *Eukharistia*!
For placing hope in Faith and faith in Communion – *Eukharistia*!
For the liturgies, the workshops, the keynotes, the symposium – *Eukharistia*!
For the stalls, the prayer spaces, the procession – *Eukharistia*!
For the youth space, the army, the travelling community – *Eukharistia*!
For the memories, the meeting, the music, the meals – *Eukharistia*!
For the communion with Christ and with one another – *Eukharistia*!

BRENDAN O'REILLY

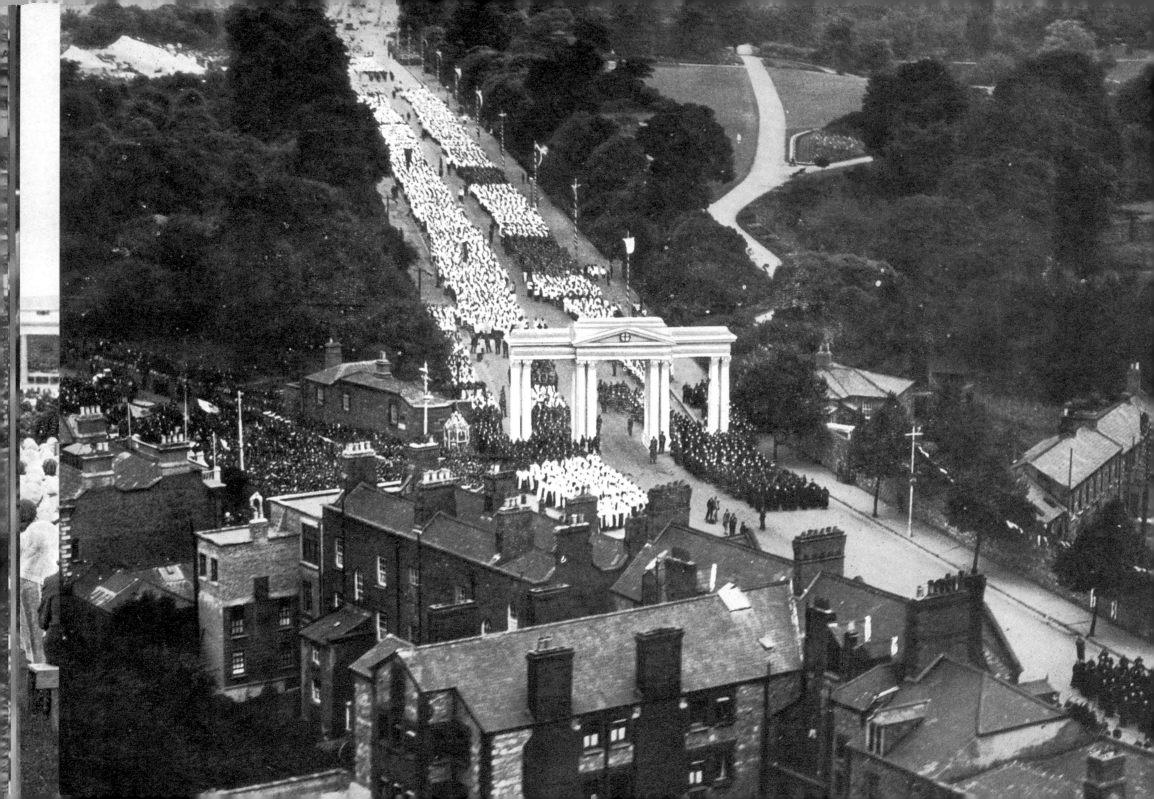

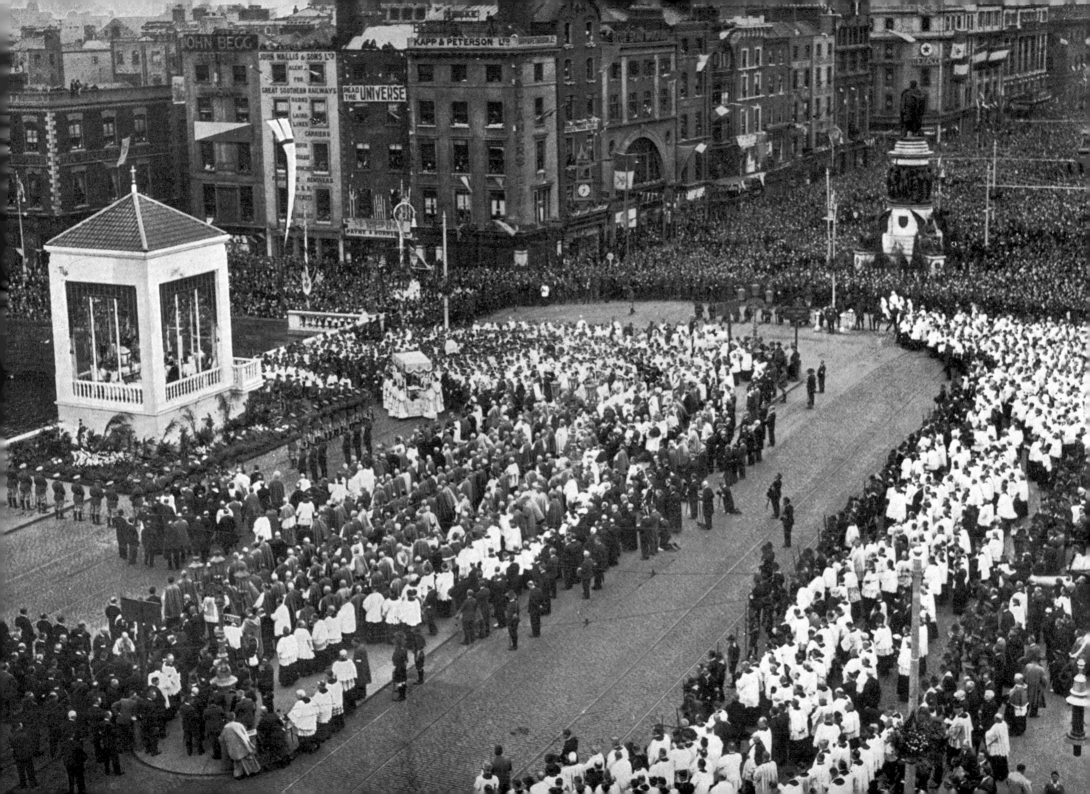

Some international and national newspaper comments taken from **The Thirty-First International Eucharistic Congress, Dublin 1932 – A Pictorial History,** published by Veritas in 1933

### L'OSSERVATORE ROMANO (OFFICIAL ORGAN OF THE VATICAN)
Here [in Ireland] every sphere of life is affected by this great event – from the schools which are closed to the business houses which have given their employees a short holiday. The newspapers from the first page to the last are full of notes and comments on the religious events.

### THE GUARDIAN (LONDON)
It [the Congress] was, of course, a marvel of organisation, of 'showmanship', perhaps some would say, but no amount of organisation would have been of the slightest avail had there not been present the overwhelming devotion of Celtic Ireland to that which has been its solace through centuries of oppression, misery and civil war.

### FIGARO (PARIS)
I do not believe that it is possible to witness in any other part of the world a spectacle such as we have just seen in Dublin. ... here one felt that one heart was beating in a whole nation.

### L'ITALIA (MILAN)
The Irish have belied their reputation as a cold, imperturbable, Nordic people. Instead they have shown themselves as enthusiastic, as exuberant as any Southern race. ... Everywhere there appears a wonderful devotion to the Blessed Eucharist. These children of St Patrick enjoy a faith at once enthusiastic and respectful.

### THE WESTERN PEOPLE
From the most remote corners of the earth have come pilgrims to Dublin for the Eucharistic Congress. They return with a new and truer conception of the Irish, of their faith and fidelity to the Church, of their joy in the honour which was given to Ireland in this eventful year.

### IRISH WEEKLY INDEPENDENT
It is questionable if any other country in the world could manifest such edifying devotion and so much enthusiasm for a religious purpose as Ireland has shown for the Eucharistic Congress. Dublin, in particular, has honoured the occasion in a manner which, we venture to assert, could not be paralleled in any other city of similar size and importance. Possibly the capitals of great powers could produce more gorgeous effects in an area less extensive through expenditure of huge sums of money, but we are convinced that nowhere else could there be found the same universality of effort, the same unity of thought and desire influencing rich and poor, prince and peasant, the merchant in his mansion and the worker in his cottage.